*The Copernicus Complex: Our Cosmic Significance
in a Universe of Planets and Probabilities*

*Gravity's Engines: How Bubble-Blowing Black Holes
Rule Galaxies, Stars, and Life in the Cosmos*

Extrasolar Planets and Astrobiology

THE
ZOOMABLE
UNIVERSE

SCIENTIFIC AMERICAN / FARRAR, STRAUS AND GIROUX

NEW YORK

THE ZOOMABLE UNIVERSE

AN EPIC TOUR THROUGH COSMIC SCALE, FROM ALMOST EVERYTHING TO NEARLY NOTHING

CALEB SCHARF

ILLUSTRATIONS BY RON MILLER

AND 5W INFOGRAPHICS

Scientific American / Farrar, Straus and Giroux
18 West 18th Street, New York 10011

Printed in China
First edition, 2017

An excerpt from *The Zoomable Universe* originally appeared, in slightly different form, in *Scientific American*.

Library of Congress Cataloging-in-Publication Data
Names: Scharf, Caleb A., 1968– | Miller, Ron, 1947– illustrator.
Title: The zoomable universe : an epic tour through cosmic scale, from almost everything to nearly nothing / Caleb Scharf ;
 illustrations by Ron Miller.
Description: First edition. | New York : Scientific American / Farrar, Straus and Giroux, 2017.
Identifiers: LCCN 2017001222 | ISBN 9780374715717 (hardcover) | ISBN 9780374279745 (ebook)
Subjects: LCSH: Cosmology—Popular works. | Large scale structure (Astronomy)—Popular works. | Inflationary
 universe—Popular works. | Astrophysics—Popular works.
Classification: LCC QB982 .S337 2017 | DDC 523.1—dc23
LC record available at https://lccn.loc.gov/201700122

Designed by Jonathan D. Lippincott

Our books may be purchased in bulk for promotional, educational, or business use. Please contact your local bookseller
or the Macmillan Corporate and Premium Sales Department at 1-800-221-7945, extension 5442, or by e-mail at
MacmillanSpecialMarkets@macmillan.com.

www.fsgbooks.com • books.scientificamerican.com
www.twitter.com/fsgbooks • www.facebook.com/fsgbooks

Scientific American is a registered trademark of Nature America, Inc.

10 9 8 7 6 5 4 3 2 1

To all explorers. Of the past, present, and future.

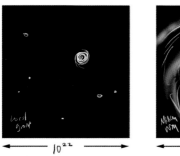

local group

10^{22}

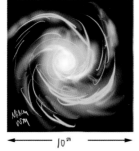

Milky way

10^{21}

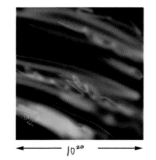

10^{20}

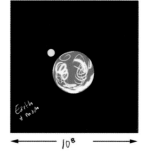

Earth & moon

10^{8}

1 m

10^{-1} m

10^{-2} m

10^{-3} m

ultraviolet
viruses
molecules of oxygen

10^{-7}

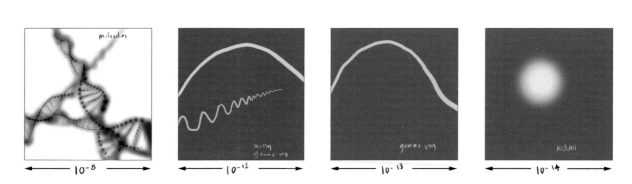

molecules

10^{-8}

x-ray
gamma ray

10^{-12}

gamma ray

10^{-13}

nucleus

10^{-14}

CONTENTS

PREFACE

Do you want to hear the most epic story ever?

A long time ago the atoms in your body were spread across trillions of kilometers of otherwise empty space. Billions of years in the past there was no hint that they would eventually come to be configured as your eyes, your skin, your hair, your bones, or the eighty-six billion neurons of your brain.

Many of these atoms came from deep inside a star—perhaps several stars, themselves separated by many trillions of kilometers. As these stars exploded, they hurled matter outward in a flood of scorching gas that filled a small part of one galaxy out of hundreds of billions of other galaxies, arrayed throughout a gaping maw of space and time almost a trillion trillion kilometers across.

Despite being scattered in the cosmos, these atoms eventually became part of a world, our world, Earth. They cooled and condensed together, drawn by gravity, becoming new stuff, a billion trillion times denser than when they were just floating in space. For four and a half billion more years they shape-shifted into lots of different guises.

Some of these atoms were part of the very first microscopic bubbles of living complexity in otherwise empty oceans and continents. And many of the very same atoms have been discarded and picked up a billion or more times as they've traveled through Earth's environment.

They've been in the shell of a trilobite, perhaps thousands of trilobites. They've been in tentacles, roots, feet, wings, blood, and trillions, quadrillions of bacteria in between. Some have floated in the eyes of creatures that once looked out across the landscapes of a hundred million years ago. Yet others have nestled in the yolks of dinosaur eggs, or hung in the exhaled breath of a panting creature in the depths of an ice age. For other atoms this is their first time settling into a living organism, having drifted through eons in oceans and clouds, part of a trillion raindrops or a billion snowflakes. Now, at this instant, they are all here, making you.

Each atom is itself a composite that's about a tenth of a billionth of a meter across—sitting on the precipitous edge of a universe between our perceived reality and the quantum world. Electrons hazily occupy much of the atom's empty space. Protons and neutrons cluster in a nucleus, a hundred thousand times smaller than its atom, and are themselves composed of other stupendously small things, quarks and gluons. An electron may have no meaningful property of size but can be thought of as ten million times smaller than the nucleus. And, at some point, 13.8 billion years ago, all these components of all the atoms in the universe were squeezed into a far smaller, hugely energetic origin of space and time. Although that origin is now vastly expanded, we're still inside its envelope, along with any being that may exist a billion light-years from here. We're not truly disconnected, even now.

It's quite a tall tale. Except this is not fiction. It's our current best shot at recounting what has really happened in the past 13.8 billion years.

The purpose of *The Zoomable Universe* is to try to capture more of this story, to lead you through what we know (and what we don't) about the entirety of nature. To do that we've turned to a tried-and-true approach: the simple premise of a tenfold zooming view to tour the universe, from the edge of the observable cosmos to the innermost knots of reality.

The conceit of a journey through the scales of nature is not new, and doing it scientifically goes back at least as far as *Micrographia*, published by Robert Hooke in 1665. Works like the seminal 1957 book *Cosmic View: The Universe in 40 Jumps*, by Kees Boeke, and the short films *Cosmic Zoom*, by the National Film Board of Canada (1968), and *Powers of Ten*, by Charles and Ray Eames (1977), as well as many derivatives in subsequent years, demonstrate our universal love of cosmic journeys.

It seemed that the time was ripe to make a contribution that not only brought the core material fully up to date but added focus on the intricate connectivity of the universe. Atoms

here in my hand are related to atoms over there, or on the next planet, or halfway across the cosmos. The physics that operates inside us is the same that operates on other scales, and at other cosmic times. And the patterns and emergent phenomena that infuse our day-to-day experiences share rules and properties in countless surprising ways throughout nature.

From fingers and toes to modern mathematics and measurements, we can all grasp the notion of powers of ten, sizes that shift by ten times or by a tenth. Chain these sliding scales together and we have a language for expressing the continuities and relationships of nature that extend far outside our ordinary everyday experience. The powers of ten let us zoom from almost everything to nearly nothing.

This book is a synopsis, a cheat sheet if you will. It can't recount every exact detail of the contents and history of the universe. Instead, it treats the reality we know as a zoomable map with a preset path to follow. In video-game parlance, it's a "rail shooter." That rail follows the physical scales of the cosmos—starting at the top and zooming on down.

As we wrote and illustrated this journey, we agonized over how to build this rail. The cosmos has three dimensions of space, and that tricky thing we call time. There are also trillions of interesting things to take a look at along the way. We've tried to balance the idea of a "grand overview" with making sure we visited some very, very cool places en route.

Some of the waypoints are intellectually challenging—even in Chapter 1 you'll have to contend with the strange concept of dark matter, an expanding universe, and even stranger things like multiple universes and multiple versions of you. In Chapter 3 you'll have to grapple with the majestic origins of the solar system. By Chapter 6 you'll be puzzling over the nature of consciousness, and by Chapter 9 you'll be tackling interpretations of quantum mechanics. Don't worry— the beautiful illustrations and infographics will help delight and inform you along the way.

We hope you enjoy finding your own connections among the gloriously varied pieces of data and knowledge that bring our vision of reality together. Remember, it's your universe as much as anyone else's.

THE
ZOOMABLE
UNIVERSE

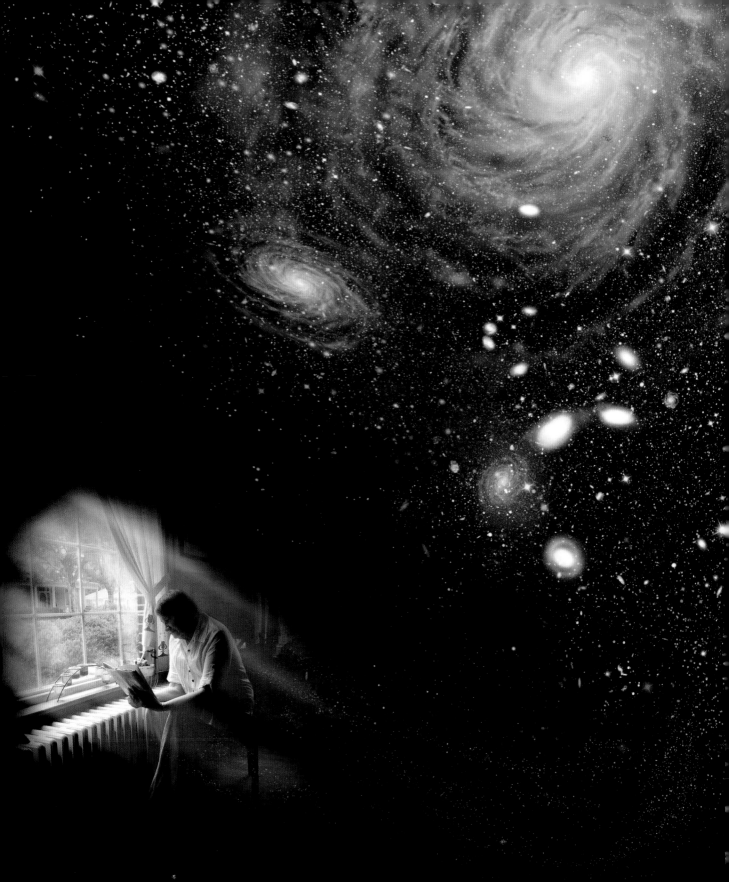

ALMOST EVERYTHING

10^{27}, 10^{26}, 10^{25}, 10^{24}, 10^{23} meters

From about 93 billion light-years to 10 million light-years

From the diameter of the cosmic horizon to the size of the Local Group of galaxies

It's a summer morning. You're sitting in a sunlit room holding this book, reading this page, and about to start a journey through cosmic scale.

Looking up, you notice that tiny specks of glowing dust are caught in the beams of light streaming through the windows. These bright pinpoints loft and swirl in the air currents, like a swarm of mysterious creatures.

The specks are microscopic, yet if the whole room were to represent the size of the observable universe, each of these dusty motes would be the size of an entire galaxy of stars.

Now follow a single sunlit speck. This is our galaxy, the Milky Way. It is home to more than 200 *billion* stars, and at least that number of planets. These stars and planets span a structure that is a hundred thousand light-years across—a distance of more than nine hundred thousand *trillion* kilometers. At a walking pace, it would take you twenty trillion years to cross this object.

Packed deep inside, hidden among these billions of other worlds, is one particular planet we call Earth. This world is a modest rocky orb with a thin coating of crystallized mineral crust atop a hot interior, lightly painted with water and atmosphere. It orbits a lonesome star that we call the Sun—one star, only 4.5 billion years old in a 10-billion-year-old galaxy.

Now think about all the things that you know and experience in your life. Your family,

friends, dogs, cats, small furry rodents, horses, houses, couches, beds, pizza, apples, oranges, trees, flowers, insects, dirt, clouds, water, snow, rain, mud, sunshine, and starry nights.

Then think about all the people who have ever lived (a total of around 110 billion individual, biologically modern humans) and all that *they* knew in their lives. All these people, billions upon billions of them, experiencing their surroundings for centuries, decades, years, months, days, hours, seconds, and the blink of an eye.

That's a lot of special moments for human beings. But for 3.5 billion years before we came along, living things swarmed the Earth, from bacteria and archaea to multi-cellular clumps, from trilobites to insects, dinosaurs to cephalopods. Trillions of living entities slithered around every conceivable niche, compelled into existence by varying potentials of chemical energy and chance. During every passing moment of those many years, all these organisms were being sculpted and battered by natural selection, and driven by the restless engines of molecular mechanics.

The sum total of that, every single last bit of it, has existed on this one world—a vanishingly small mineral dot among billions of mineral dots, all held within a single dust mote that you watch floating through a sunny room that is the universe as we know it.

This one-mote galaxy that we call the Milky Way is a microscopic part of a wrinkly, web-like ocean of matter. That ocean sustains more than 200 billion *other* galaxies. These galaxies range from small to enormous, some isolated, some in the midst of messy collisions. And these are merely the galaxies from which light has had time to reach us in about thirteen billion years—they're within our "horizon," the horizon of light travel time, like the walls of your room.

This cosmic sprawl is also awash in electromagnetic radiation, energy that exhibits both wave- and particle-like behavior, packaged as massless units called photons racing to and fro across space. Some of this radiation is the product of the early and hot history of the place that we generally call the universe. Other photons are from specific, individual sources: stars, supernovas, warmly glowing young planets, cosmic crashes and shock waves, possibly even plaintive missives hurled between technological civilizations—or not.

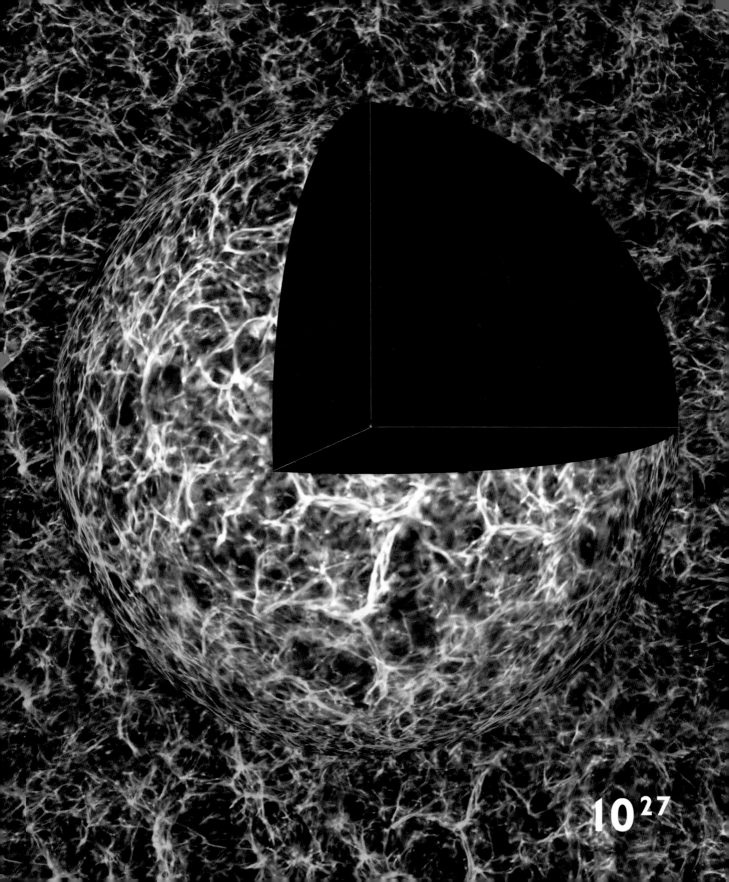

10²⁷

Add up all the recognizable matter and there may be 10^{80} particles, like protons, neutrons, electrons, and other subatomic items, inside our cosmic horizon. Although that's a very big number, it's also really just peanuts, because there are probably a *billion* times more photons zinging around, making a beastly total of 100,000 of these electromagnetic-energy carriers in the observable cosmos.

Yet this atomic and subatomic stuff is barely 16 percent of what we think is the total matter content of space. It's the part that our eyes and instruments can see. Astronomical evidence suggests that there is an invisible shadow universe of still-mysterious subatomic particles that constitute the bulk of matter in the cosmos, some 84 percent of the mass. Here's an underworld of dark matter, dominating entire galaxies with its gravitational pull, but unseen by us.

Even stranger is that all the normal and dark matter is swimming in a space-time fabric that is seething with submicroscopic quantum phenomena. These ethereal quantum manifestations

are too small, too brief, and too strange to be readily noticeable—except in a cumulative and quite terrifying effect that we now call dark energy. Astronomers think that dark energy is the prime suspect behind the accelerating expansion of the cosmos. Space-time itself—the underlying fabric of the universe as a whole—is swelling more and more with every passing hour.

That is, in essence, what Everything really is.

Are you tempted to ask what comes next? What is beyond the phenomenon we call Universe, beyond the Everything? What might be "outside" the sunlit room of our observable reality? These are great questions, and in a very real sense anything "outside" our universe must for now be simply *not universe*.

The start of your journey through this book and through all known scales of reality is at that edge between known and unknown. This is a place hovering at our cosmic horizon, the scale set by the distance light travels during the age of the universe, the threshold of the doorway into your room. Within is the observable universe. Just outside is a still-mysterious labyrinth.

The Observable Universe

It takes light a few times 10^{-44} seconds to travel 10^{-35} meters—the smallest meaningful distance in physics. By contrast, some of the photons of microwave radiation that are hitting your body have taken 13.8 billion years to reach you, traversing a distance that has now expanded to more than 10^{26} meters. Between these two scales is all that we can observe, maybe all that we'll ever know.

10^{-10}
ATOMS
Building blocks of chemistry. Our bodies contain some 10^{27} atoms.

10^{-7}
VIRUSES
Infectious agents for life. At least 10^{31} viruses exist on Earth; placed end to end, they would stretch 100 million light-years.

10^{-20}
QUARKS
These fundamental particles are a constituent of hadronic (ordinary) matter, such as protons and neutrons. Quarks have mass, electric charge, spin, and a property we call color charge.

10^{-15}
PROTONS
Protons (along with neutrons) can form atomic nuclei. The rest mass of a proton is more than 1,800 times that of an electron.

SIZE SCALE (in meters)

PLANCK SCALE ———→

| 10^{-35} | 10^{-30} | 10^{-25} | 10^{-20} | 10^{-15} | 10^{-10} | 10^{-5} |

A scale so minuscule that we need a quantum theory of gravity to describe what's going on. There are as many orders of magnitude in scale from here to a speck of dirt as from a speck of dirt to the entire observable universe.

MIDWAY ———→
0.1 millimeters (10^{-4} meters) is halfway between 10^{-35} meters and 10^{27} meters on a logarithmic scale: as large compared to the Planck scale as the whole observable universe is to 0.1 millimeters.

TIME SCALE

Space and time are intimately connected. The speed of light sets the limits for cause and effect (causality) in the observable universe.

3.3 YOCTOSECONDS (10^{-24})
for light to travel across a proton

0.33 PICOSECONDS (10^{-12})
for light to travel 0.1 millimeters

10^{21}
GALAXIES
We live in a modest galaxy of some 200 billion stars. The smallest galaxies may contain a few million stars; the largest may contain trillions of stars.

10^7
PLANETS
Planet-like objects run from hundreds of kilometers in diameter to well over 100,000 kilometers.

10^{10}
STARS
The smallest stars are 10^8 meters across. The Sun is 10^9 meters. The largest stars reach sizes of more than 10^{11} meters.

10^{26} • RADIUS OF THE OBSERVABLE UNIVERSE

10^{-1}	10^0	10^1	10^5	10^{10}	10^{15}	10^{20}	10^{25}
	1 m	10 m			1 light-year		

10^{-3}

HUMAN EXPERIENCE
This is our narrow slice of scales in the universe. Our biological awareness seldom strays below a few millimeters or above a few kilometers. That is 6 orders of magnitude out of some 62.

10^3

THE LIMIT OF THE OBSERVABLE UNIVERSE
The cosmic horizon, the farthest place that light has had time to reach us from. Any observer in the universe will be at the center of their own horizon, their own bubble of the known.

3.3 NANOSECONDS
(10^{-9})
for light to travel 1 meter

There are about 2.5 billion (10^9) seconds in a human lifetime.

500 SECONDS
for light to travel from the Sun to the Earth

100 MILLION SECONDS
(10^8)
for light to travel from the Sun to Proxima Centauri

1 HUNDRED QUADRILLION SECONDS
(10^{17})
for light to travel from cosmic horizon to us

In truth, we think that our universe must continue on for a while beyond that horizon of the known. The universe from which light has *not* yet had time to reach us may be far, far larger than the part we can see. Some estimates, based on analyses of the known geometry of space-time, suggest that the "full" universe could extend at least 250 cosmic horizons farther. Other estimates, based on the very rapid expansion—or inflation—of the universe in its very early youth, suggest that the universe may be on the order of 10^{23} times larger than the part we will ever see, or ever access.

If this is correct, the universe might contain places that are, in effect, repeats of where we find ourselves. Those repeats could even include solar systems, planets, and life-forms that bear an uncanny resemblance to the ones we know.

It's an unsettling thought, that the roll of cosmic dice might have happened enough times to reproduce Earth and its history. But lurking in our hypotheses about the fundamental nature of the universe and its physical origins are ideas that are even stranger.

Another world, beyond the observable universe?

To produce the cosmos that we observe, including the "shape" of its space-time and its relative uniformity on the largest scales, scientists have invoked the phenomenon of cosmic inflation. Very early in time, a mind-bogglingly brief 10^{-36} seconds after the Big Bang, there was likely an episode of enormously rapid expansion of space-time—where the universe grew by more than a trillion trillion times until the cosmic clock hit 10^{-32} seconds. That's like a small pore on your skin inflating to the size of the Milky Way galaxy over a period that is a hundred quadrillion times less than some of the shortest intervals of time human devices have ever registered (about ten-quintillionths of a second).

Pocket universes

One outcome that physicists have proposed for this inflation produces an array of "pocket" universes, so many in number that it makes your eyes water; possibly 10-to-the-10-to-the-10-to-the-7 universes. Not only would there be a spectacular number of universes just like ours—there would be a spectacular number of universes *not* like ours. If true, this "multiverse" would contain other versions of all of us as well as all our evil twins.

There are, to say the least, some disturbing aspects to this possibility. It would mean that any decision you make—good or bad—would be made many times elsewhere, and in many different ways. So does it really *matter* if I pick up that piece of litter when a trillion other versions of me will pick it up a trillion other times somewhere else in the multiverse? Should we bother discovering the secrets of the universe when it's only one among many, and not as unique as we once thought?

We're left to wonder for now, and to go and make a strong cup of tea.

VIEW FROM A FAR HORIZON

In this book our journey begins at the place that matches the reach of our current knowledge: we'll start our deep dive into powers of ten at a scale of 10^{27} meters (an octillion meters). We choose this scale because if we could measure the physical diameter, the extent, of the universe between the bounds of the cosmic horizon *at this instant in time*, we would find it to be about ninety-one billion light-years, or 860,951,000,000,000,000,000,000 kilometers, across— roughly 10^{27} meters.

If you're quick-witted you might query that number— since the universe is only 13.8 billion years old, how can it be physically larger than the distance light would travel in that time? The answer is universal expansion—that swelling of space-time. As a consequence, at this very instant, you'd measure it to be larger than you might expect.

We can actually map aspects of the cosmic horizon. As the universe expands, it cools, since the photons racing

The next step, a descent into the cosmic web

10^{26}

through space get their wavelengths stretched out and lose energy. If we could go back in time, we'd find that the universe gets hotter and hotter. Until the universe was around 379,000 years old, its average temperature was above 3,000 Kelvin (4,940°F)—too hot for electrons to be bonded in atoms. The photons racing through space were continually scattered by these free electrons. This made the young cosmos a "fog" impenetrable by electromagnetic radiation.

But shortly after this time, as the universe cooled, electrons and protons could bond to form neutral atoms of hydrogen that seldom scattered visible light. The fog lifted and the photons could travel without interacting with any particles. We can detect these same photons today—now greatly stretched out in wavelength and causing an unavoidable microwave hum across space. That background noise is, in effect, a glimpse of the cosmic horizon; it's as far back as we can see.

With our most sensitive telescopes we can peer into the universe to find the first stars and galaxies (also close to thirteen billion years ago). These infant condensations of matter were seeded by the tiny irregularities of the early inflating cosmos, irregularities that gravity grew by pulling more and more matter together. And all the way from these galactic infants to the galaxies sharing our patch of the universe, we've succeeded in constructing great maps of the cosmic landscape.

These maps tell us that the cosmos is both foamy and granular. A bit like the soapy scum left from an emptying sink or bath, the foam is seen in outline, traced by a three-dimensional web of dark as well as luminous matter.

Peppering that web are dense condensations where grav-

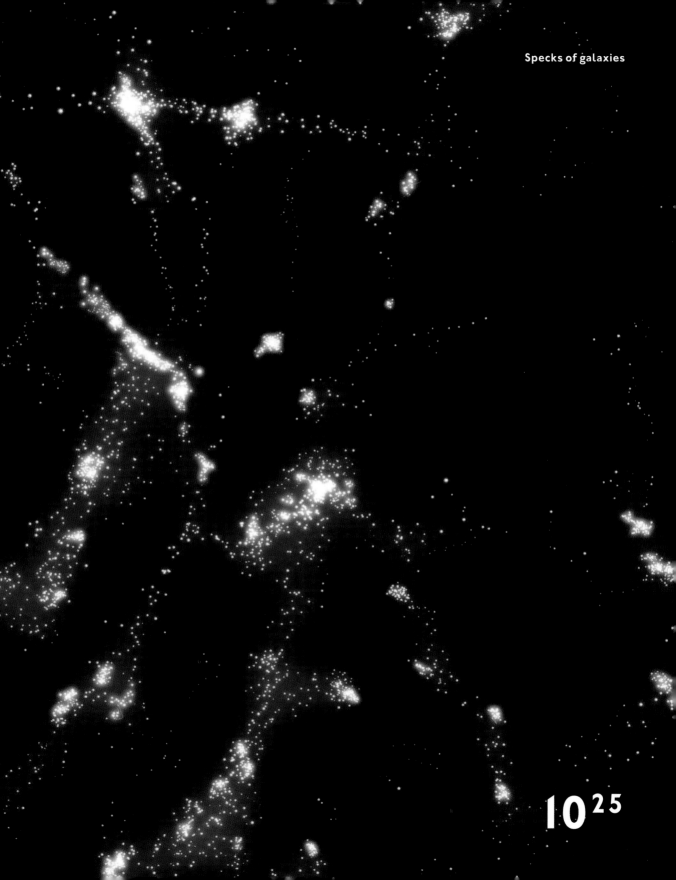

Specks of galaxies

10^{25}

Galaxies along a filament of large-scale structure

ity has overwhelmed the expansion of space-time. Here and there are superclusters of galaxies a trillion trillion meters, or hundreds of millions of light-years, across. Within these superclusters are distinct clusters of galaxies, broad and deep wells of gravity that hold swarms of hundreds, sometimes thousands, of galaxies, all orbiting in and out of the center, together with vast pools of hot gas and cold dark matter spanning tens of millions of light-years.

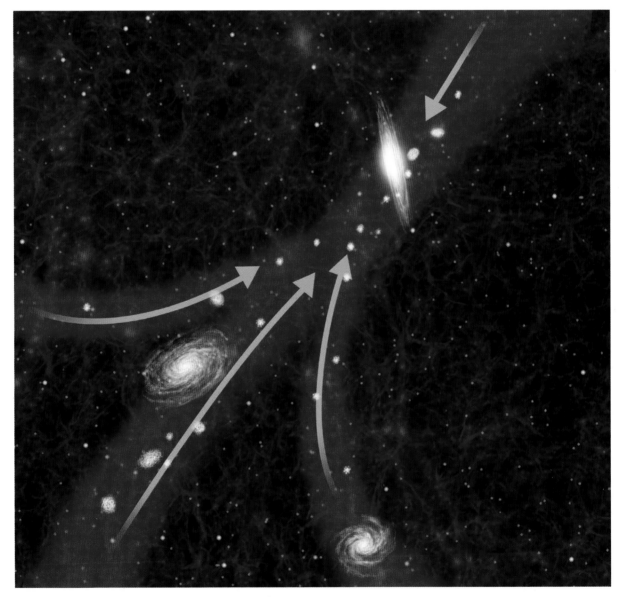

Matter flows in large gravitating structures.

There are tiny galaxies, big galaxies, and really big galaxies. Within these galaxies are the minuscule dense forms of stars and other stellar remnants, as well as the most compact objects in nature: black holes that range from a mass ten times that of our Sun to masses tens of *billions* of times larger.

Remarkably, on the journey from 10^{27} meters to 10^{23} meters, in just five factors of ten we transition down from the size of the observable universe (the cosmic horizon) to our own cosmic neighborhood of Local Group galaxies.

To put that another way, we've gone from a volume containing *almost* Everything (more than 200 billion galaxies) to a volume containing between 50 and 60 galaxies in our vicinity.

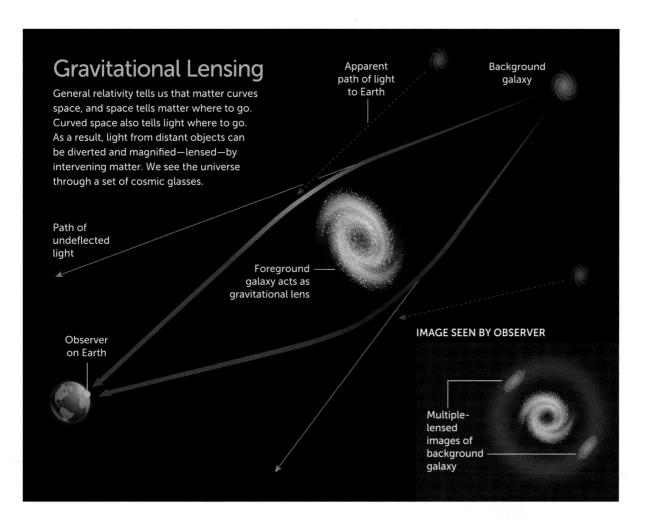

Gravitational Lensing

General relativity tells us that matter curves space, and space tells matter where to go. Curved space also tells light where to go. As a result, light from distant objects can be diverted and magnified—lensed—by intervening matter. We see the universe through a set of cosmic glasses.

Apparent path of light to Earth

Background galaxy

Path of undeflected light

Foreground galaxy acts as gravitational lens

Observer on Earth

IMAGE SEEN BY OBSERVER

Multiple-lensed images of background galaxy

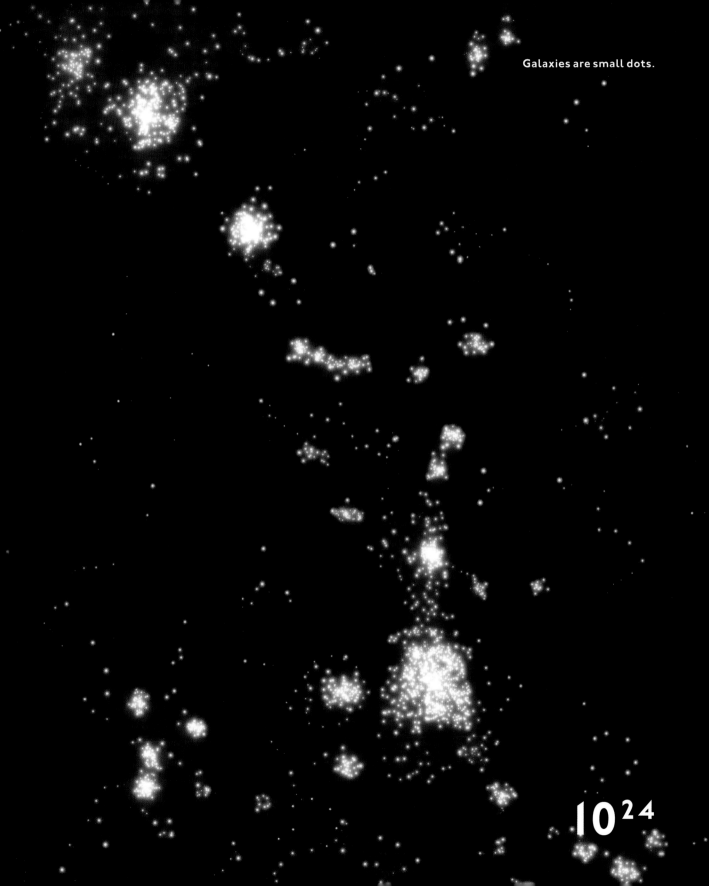

Galaxies are small dots.

10^{24}

Or think about a distance of one kilometer (half a mile, perhaps your morning walk) compared to the size of a coin in your pocket. That's the contrast between the scale of the entirety of the known universe and our intergalactic patch within it.

Yet you've also only just begun this cosmic voyage. In the rest of this book are another *fifty-seven* orders of magnitude in scale we need to travel through. Ready? Then turn the page and follow on down!

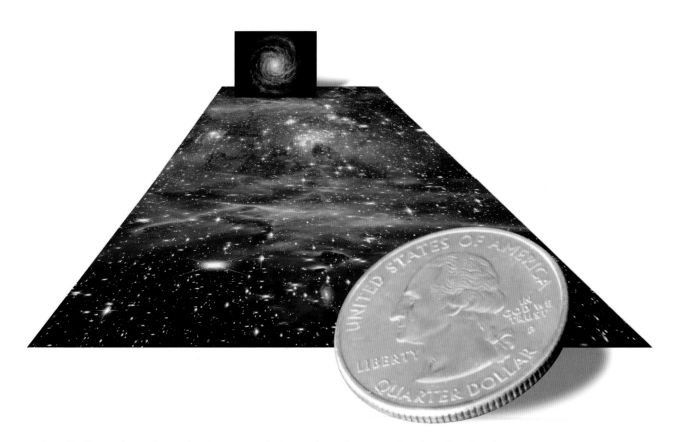

In only five orders of magnitude, we reach the pocket-change scale of our local universe.

10^{23}

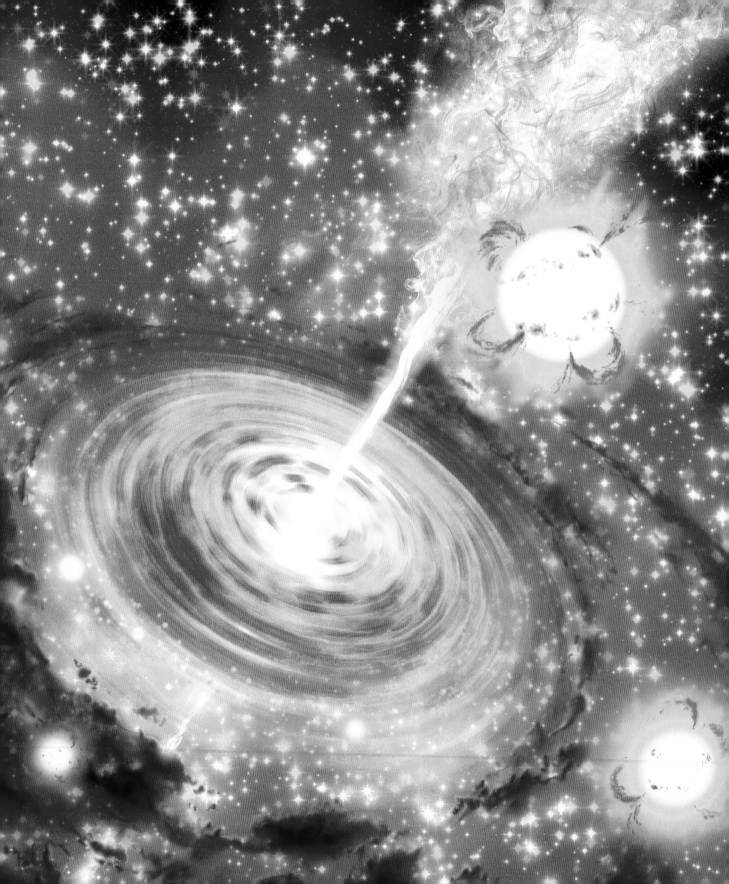

DARKNESS AND LIGHT

10^{22}, 10^{21}, 10^{20}, 10^{19}, 10^{18} **meters**

From about 1.06 million light-years to 106 light-years

From about 8 to 10 Milky Way diameters to the size of a giant molecular cloud

Imagine that you are an all-powerful alien being who decides to scrunch up all the stars in the Milky Way so that they are packed next to one another. By getting rid of all the space in between, you can fit these stars into a cube only about 8 billion kilometers (or fifty-four times the radius of Earth's orbit) on each side. That cube, containing some 200 *billion* stars, fits neatly within the orbital diameter of Neptune in our solar system. In other words, the galaxy has plenty of surplus room between its stars.

Of course, physics wouldn't actually let you do this, at least not without making a lot of mess. The problem with putting this much mass in one place is that you'd wind up making a black hole. Why? Because the gravitational pull of all those stars on one another would be irresistible. Weirdly, though, the size of the black hole containing the mass of the 200 billion or more stars of the Milky Way would be much bigger than our imaginary cube of stars by a factor of about 146.

That's because very massive black holes are actually rather low density if you treat their outermost extent as the measure of their size. This may feel counterintuitive, but the size of a black hole—the event horizon (the point of no return, the radius surrounding the hole's mass from within which nothing can escape)—increases in lockstep with the hole's mass. In other words, if you double the black hole mass, you double the radius of the event horizon.

That's very different from what happens with regular objects. For example, add two

Compact matter in black holes strongly warps space and time.

identical balls of dough together, and the new radius of the combined ball is not twice what it was; it's only about 26 percent larger. Why? Because for ordinary materials in a sphere the radius grows as the cube root of the mass—double the mass and you only increase the size by 26 percent. So if we treat the event horizon of a black hole as a measure of its physical size, the *average* density of matter within its bounds can end up being very low. A black hole with a mass three billion times that of the Sun would appear to be only as dense as the air we breathe! But this is a bit of cosmic misdirection, because our formal understanding of these objects tells us that all of a black hole's mass is actually concentrated in a tiny, hidden, infinitely dense region at its center.

Where such giant singularities exist, in the cores of most large galaxies, they also often look like the precise opposite of what we might expect. Yes, black holes are black, but you might not think so, because they can generate enormous amounts of light. Gas, dust, stars, planets, and who knows what else gets accelerated, shredded to bits, and heated if close enough to a black hole. In the process, energy spews outward, from above the event horizon and before the point of no return. With enough infalling matter, a spinning black hole can convert mass to energy with higher efficiency than even nuclear fusion. The most luminous cases across the universe shine with the power of hundreds of trillions of suns.

Matter at its most compact, like in a black hole, can surprise even the most scientific among us. At the other extreme, all that empty space in a galaxy like the Milky Way is also surprising.

NECESSARY EMPTINESS

Most of us experience physical loneliness at some point in our lives: lost in an unfamiliar city, alone in a house, or abandoned in a deep, dark wood by scheming relatives. But intergalactic space and interstellar space—between the galaxies or between the stars in the typical parts of a galaxy—are actually the two loneliest places you might ever wind up in. In these "inter-zone" environments it can be a very, very long distance between safe havens, devoid of much of anything at all.

If you were a hapless cosmic hitchhiker stranded between the stars of the Milky Way, your body would represent a concentration of matter a *hundred million trillion* times greater than the

sparse interstellar space around you. To put that another way, take a look at the tip of your little finger. That pinky end contains about 10^{23} atoms. That number is the same as the total number of atoms in a sphere of about 100 *million* cubic kilometers of typical interstellar void.

Consequently, as a stranded traveler you can take a small comfort from the fact that cosmically you are also quite special. If you randomly stuck a pin in a map of the observable universe there is an exceedingly low probability that it would land anywhere with as much matter richness as your body, or even any planet or star.

The strange emptiness of galaxies makes for some other interesting properties. Imagine that two galaxies are colliding—something that will happen in four billion years to the Milky Way and our neighbor Andromeda. Will the stars themselves come crashing together in such a titanic event? No, they won't. Stars are so small compared with the gulfs of space between them that it's very improbable that any will actually collide, even though their vast galactic parents are lumbering through each other.

The gravitational pull of matter in the approaching galaxies will distort and disrupt their shapes and stellar orbits, but otherwise it's as if two swarms of bugs or birds are crossing paths. The tiny stars simply slip through all the gaps between.

The scarcity of normal matter in intergalactic space is even more extreme than in interstellar space. Get stranded out there—perhaps on a reckless trip from the Milky Way to our neighbor the Andromeda galaxy—and you'd need to scoop up at least a million times more volume to concentrate matter to the same level as in your body.

At worst you'd need to scoop up *ten million* times more volume if you were in an intergalactic "void." Within the web-like distribution of matter on intergalactic scales, there are places where very little luminous material exists. These bubble-like cosmic voids can span scales of more than thirty million light-years (3×10^{23} meters). In these regions the density of matter is less than one-tenth of the average density of the universe, which makes these places quite depressing unless you enjoy emptiness.

That's not to say that voids are useless. Far from it. The expansion of space can actually take place a little faster in these places, without the gravitational pull of so much matter inside them. As a result, cosmic voids can "self-clean," piling material up around their perimeters where it pushes into the surrounding denser intergalactic space. In this way they contribute directly to the gathering of matter into the bright webs of galaxies and stars.

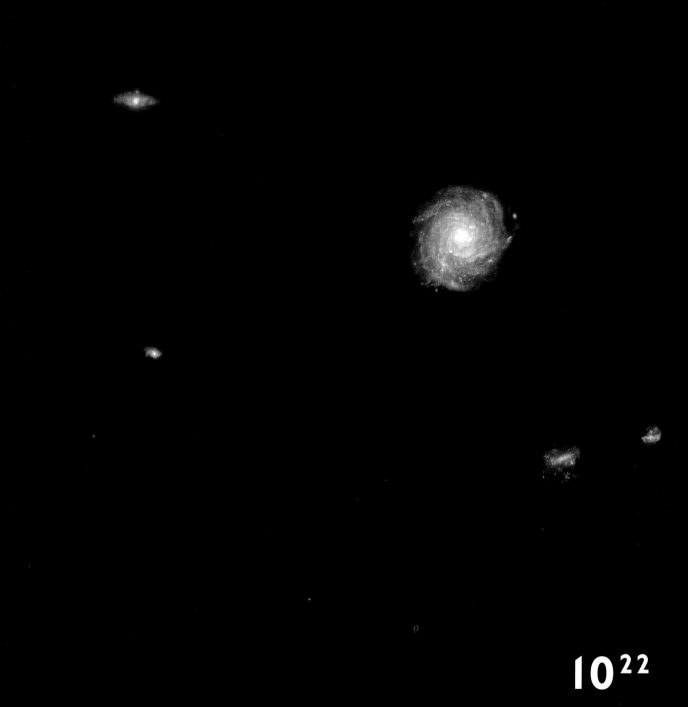

10^{22}

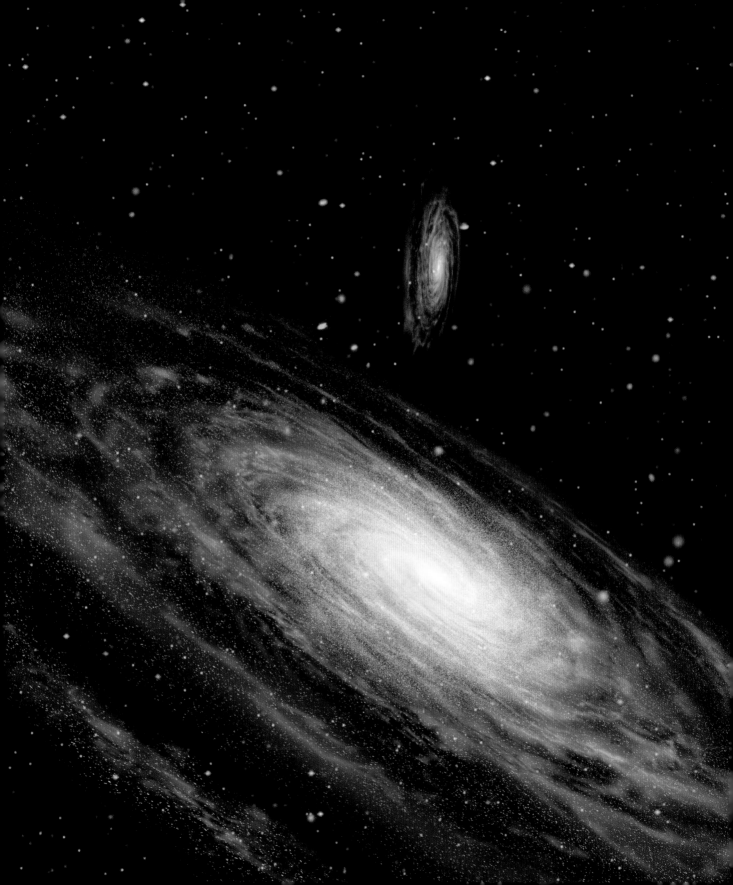

Inside the Local Group of galaxies

OUR (SLIGHTLY DYSFUNCTIONAL) GALACTIC FAMILY

The typical separation experienced by the brighter clusters and groupings of galaxies themselves is a little less isolating—only about 3 million light-years, or 3×10^{22} meters. For example, from the center of our Milky Way galaxy to the center of the nearest large galaxy, Andromeda (also known as Messier 31, or M31), there is a relatively modest gulf of about 2.5 million light-years, or 2.5×10^{22} meters.

There is also evidence of a tenuous cloud of plasma (a gas of positively charged ions and electrons) surrounding Andromeda out to a distance of about a million light-years (10^{22} meters). It's awfully thin stuff, to our human senses indistinguishable from the harshest of vacuums. But some of the components of this gaseous mixture are at a temperature of nearly a million degrees Kelvin and include carbon and silicon, as well as hydrogen and helium. We don't yet know if the Milky Way has its own similar halo.

What we *have* discovered is that the Milky Way plays ringmaster to a swarm of smaller satellite galaxies. The ones with the most stars in them are the familiar Large and Small Magellanic Clouds, a pair of dwarf irregular galaxies containing about thirty billion stars and three billion stars, respectively. But there are at least another thirty dwarf galaxies within about a million and a half light-years, most of which are likely in orbit around the Milky Way.

We've also discovered that this is not an entirely happy family. The orbit of these dwarf galaxies can result in their stars being gravitationally pulled away and stripped out into colossal "tidal streams" that wrap around the Milky Way. These stellar debris fields are clues to understanding galaxy growth. A big galaxy can sometimes put on weight by cannibalizing its smaller associates over billions of years.

These tidal streams around the Milky Way are extremely faint because they represent only a small number of stars spread across the gulf of intergalactic space. But sensitive telescopic data

can reveal them. A very good example is the Sagittarius Stream—a vast and messy loop of stars that literally encircles our galaxy, running from pole to pole.

Streams like these can also reveal clues to the fundamental shape of the gravitational field of our Milky Way. In that sense the stellar trails are natural gravity probes—measuring rods strewn across tens to hundreds of thousands of light-years.

These measurements also provide a striking reminder of what is still a central mystery of our universe: the fact that in a structure like our galaxy, the visible, luminous, normal matter of stars, gas, and dust is just a minor component. There is between ten and thirty times more dark matter than normal matter in our galaxy.

What is that dark matter? Studying the behavior of individual galaxies is one good way to tackle the puzzle. The currently favored answer is that dark matter is a species of subatomic particle that only interacts via gravity and the weak force. And this stuff doesn't reflect or absorb electromagnetic radiation.

Individually, these particles should be massive relative to other subatomic particles. That combination of properties has led to the acronym WIMPs—Weakly Interacting Massive Particles. The idea of the existence of WIMPs fits with many cosmic measurements, including the inferred gravitational fields of galaxies and clusters of galaxies, the observation of gravitational lensing, and the patterns of the cosmic microwave background radiation. The snag is that no WIMP has ever been detected directly, and a number of Earth-bound experiments are actively searching for them. It's possible that instead of there being dark matter, there is something incomplete in our understanding of the nature of gravity itself.

OLD MILKY

Whether there are WIMPs or not, our galaxy is a magnificent example of how the universe assembles matter. Spanning 100,000 light-years (10^{21} meters) and containing a total mass of visible and dark matter a trillion times the mass of the Sun, it's quite a beast.

The flattened, disk-like shape of the galaxy is a consequence of its history of

The Milky Way rises above the horizon of a rogue planet lost in space.

10^{21}

A Galactic Zoo

Galaxies can be categorized like animal species—with different histories and different mixes of stars, gas, and interstellar dust. These "species" also span many magnitudes in size and star counts.

1 Zwicky 18
Diameter:
5,200 ly

Large Magellanic Cloud
Diameter:
14,000 ly

Arp 133, "Minkowsky's Object"
Diameter:
25,000 ly

M 104, "Sombrero"
Diameter:
50,000 ly

Milky Way
Diameter:
100,000 ly

ESO 350-40, "Cartwheel"
Diameter:
150,000 ly

NGC 1316, "Fornax A"
Diameter: **220,000** ly

NGC 6872
Diameter: **520,000** ly

One of the largest known spiral galaxies

Hercules A
End-to-end
length of radio-
emitting jets:
1,500,000 ly

A giant elliptical
galaxy with a central
supermassive black
hole powering jets
of near-light-speed
particles

IC 1101
Diameter: **~6,000,000** ly

Largest known galaxy. Contains upwards
of 100 trillion stars. Sits at the center of
the Abell 2029 galaxy cluster, 1.027 billion
light-years from us.

Hercules A
at scale, for
comparison

A clash of galaxies and tidal streams of stars

formation—a process of gravitational infall, energy dissipation, and conservation of angular momentum.

There are other visible clues to our galaxy's past, including the central bulge of older stars. These are spaced closer together than stars out in the galactic suburbs of the Sun's location. Down here, close to the geometric center of the Milky Way, the spatial density of stars rises dramatically. Within 300 light-years of the center, there are about 100 times more stars in any given volume than around the Sun's neighborhood. If you go closer in, the stellar density keeps on rising—to an eye-watering peak where stars are packed a million times closer together than we're used to.

That means that stars are separated not by light-*years* but by light-*weeks* (about 10^{14} meters), and for any planets in this environment the sky will be filled with brilliant points of light. If we lived this deep in the galactic core, our night sky would be filled with a million stars as bright as Sirius, flooding our world with 200 times the light of our familiar full Moon.

In the depths of this brilliant core lies an enigmatic zone. There is a ring-like structure of gas, dust, and stars surrounding the inner few light-years of the galactic center. This helps shroud a black hole we call Sagittarius A Star (or *), a beast containing approximately four million times the mass of our Sun and surrounded by its own tightly held, swirling disk of accreting matter.

But this is just one special part of the galaxy. Old Milky is a sprawling and complicated place, where more than 200 billion stars make their way around and through a great well of gravity and interstellar filth. The most iconic features are the bright spiral arms. These are the shifting zones where new hot and luminous stars are formed. The arms are linked to slowly propagating changes in the density of stars and gas around the galactic disk, sets of ripples. In this respect the grand structures of the Milky Way, and of other similar galaxies, are somewhat illusory, the consequence of large but comparatively gentle waves of matter.

Out in our neck of the woods—26,000 light-years (2.5×10^{20} meters) from the galactic center—stars follow orbital paths that take them around the galaxy roughly every 230 million years. Our Sun is thought to be in the middle of its twentieth trip, or "galactic year." But our neighboring stars are not all perfectly synchronized in this motion. We're more like a slightly discombobulated flock of birds.

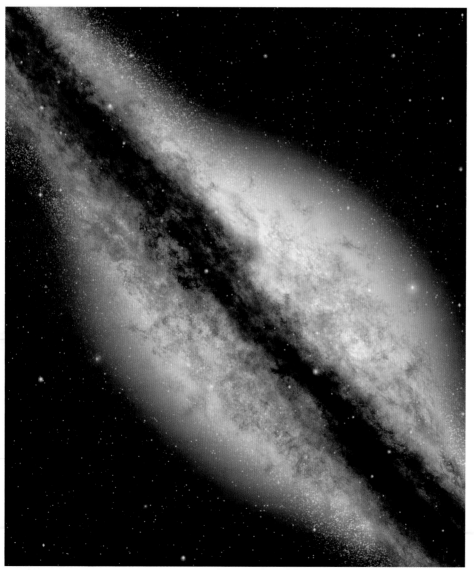

LEFT: Approaching the galactic center

OPPOSITE: Above the Orion Spur of the Milky Way

OVERLEAF: A planet close to the core of the Milky Way

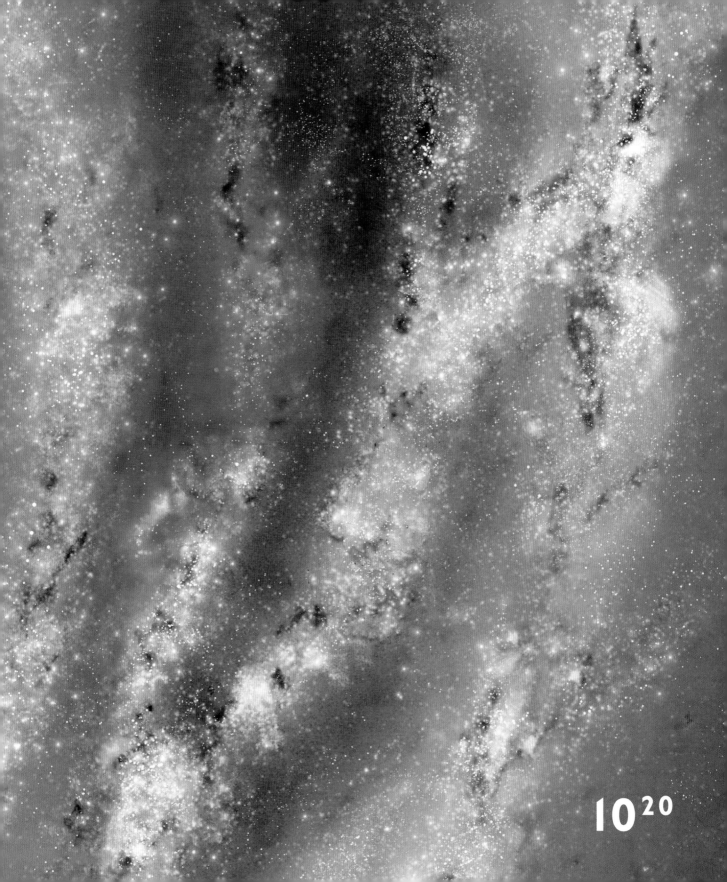

10^{20}

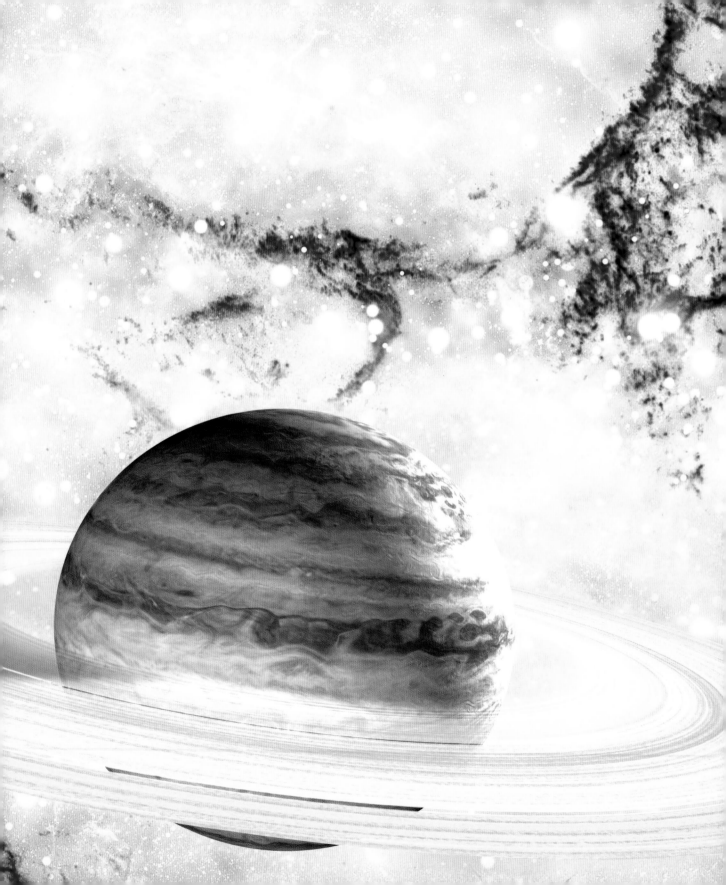

Sparse stars, a nebula, and a lost planet in the outer Milky Way

The stars around us drift in different directions at velocities of a few tens of kilometers a second. Over time these motions will mix things up, so what's close to us today may not be in a million years. In fact, we don't know where the suns are that were born with our Sun, back in a cluster of stars 4.5 billion years ago. Perhaps they are still grouped together somewhere else. Perhaps they are long dispersed.

10^{19}

Our Neighborhood Time Machine

Human history is racing out into the cosmos, carried by the light of the Earth.
Our galactic neighborhood—from nearby stars to the Andromeda galaxy—
is witnessing every stage of our species' story as that light passes by.

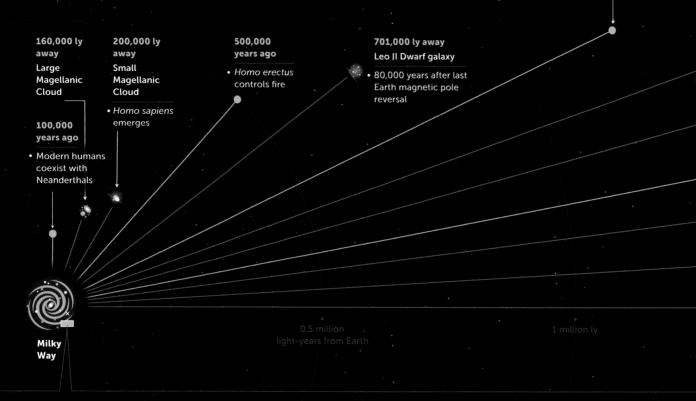

1.2 milion years ago
• *Homo antecessor*

160,000 ly away
Large Magellanic Cloud

200,000 ly away
Small Magellanic Cloud

• *Homo sapiens emerges*

500,000 years ago
• *Homo erectus* controls fire

701,000 ly away
Leo II Dwarf galaxy
• 80,000 years after last Earth magnetic pole reversal

100,000 years ago
• Modern humans coexist with Neanderthals

Milky Way

0.5 million light-years from Earth

1 million ly

A Closer View

There are about 10,000 stars within 100 light-years of us

All the events of the past 100 years—world wars; breakthroughs in physics, biology, and genetics; space exploration;
discoveries; social change; art and music—could have been witnessed by life around thousands of suns.

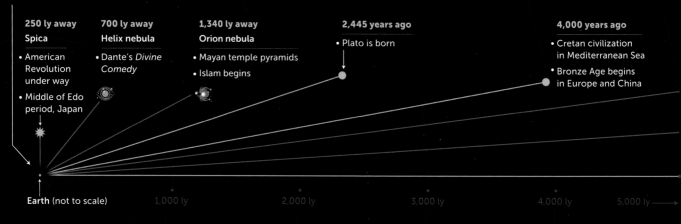

250 ly away
Spica
• American Revolution under way
• Middle of Edo period, Japan

700 ly away
Helix nebula
• Dante's *Divine Comedy*

1,340 ly away
Orion nebula
• Mayan temple pyramids
• Islam begins

2,445 years ago
• Plato is born

4,000 years ago
• Cretan civilization in Mediterranean Sea
• Bronze Age begins in Europe and China

Earth (not to scale)

1,000 ly 2,000 ly 3,000 ly 4,000 ly 5,000 ly

1.44 million ly away
Phoenix Dwarf galaxy

- Stone hand axes in use
- *Homo habilis* is extinct
- McClellan Peak lava flow in Nevada

1.63 million ly away
Barnard's galaxy

- Lantian man (*Homo erectus* subspecies) in China
- Earth magnetic pole shifting
- Stone tools existed

2 million ly away
Galaxy NGC 185

- Diversity of very large carnivores declines
- 100,000 years after largest known Yellowstone supervolcano eruption

1.9 milion years ago

- *Homo erectus* emerges

2.2 million ly away
Galaxy NGC 147

- *Homo habilis* using tools
- Solar system passing through supernova remnant

2.56 million ly away
Andromeda galaxy

- Pleistocene epoch begins
- Start of period of repeated glaciations on Earth
- *Australopithecus* is active

1.5 million ly

2 million ly

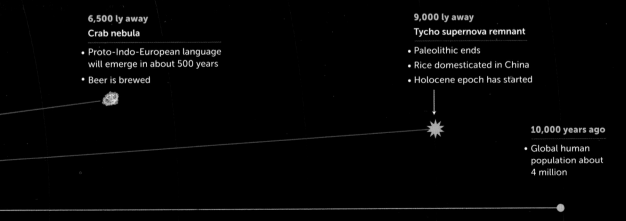

6,500 ly away
Crab nebula

- Proto-Indo-European language will emerge in about 500 years
- Beer is brewed

9,000 ly away
Tycho supernova remnant

- Paleolithic ends
- Rice domesticated in China
- Holocene epoch has started

10,000 years ago

- Global human population about 4 million

6,000 ly 7,000 ly 8,000 ly 9,000 ly 10,000 ly

Today we live in a relatively unexceptional part of the Milky Way. Within fifty light-years of us are some 130 other stars that are visible at night to the naked eye, and at least ten times more stars that are faint but still detectable with our telescopes. It's not much. It even sounds quite manageable, quite parochial. Yet our species presently has no way of crossing to even the closest stellar neighbor in less than about 40,000 years. In that sense we are an island in the interstellar barrens.

As your journey continues, we'll find out whether this is an island worth visiting.

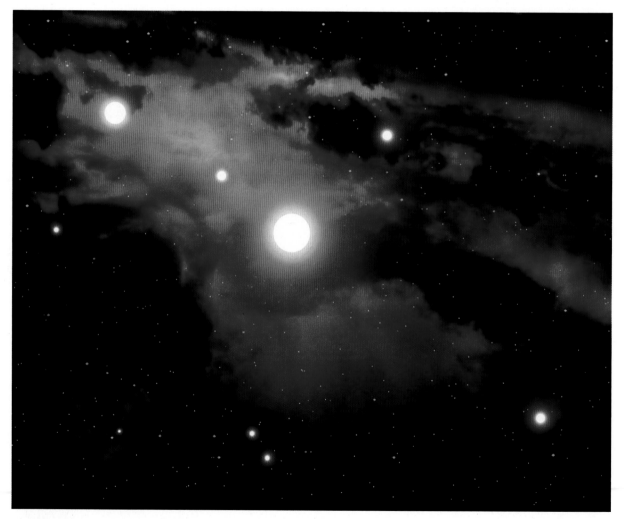

Sister stars, 4.5 billion years ago

At the center, barely noticeable, is our Sun.

10¹⁸

At the center, barely noticeable, is our Sun.

10^{18}

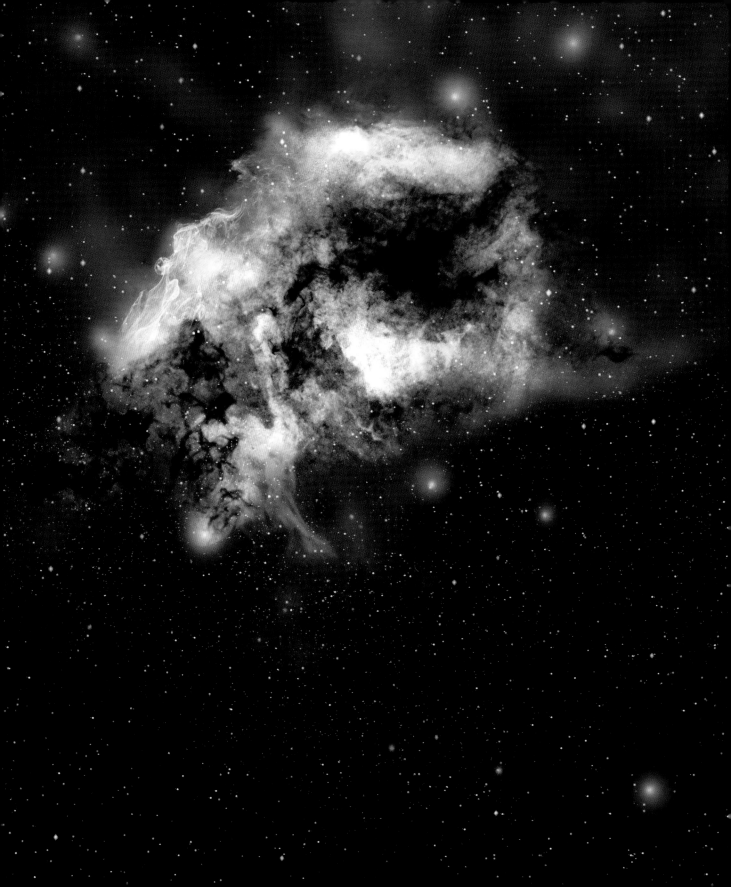

3

THE SLOW, THE FAST, AND THE FANTASTIC

10^{17}, 10^{16}, 10^{15}, 10^{14} meters

From about 10 light-years to 92 light-hours, or 668 astronomical units

From about nebula scale to the size of the inner edge of the Oort Cloud

Five billion years ago, your atoms were about ten million times more widely spread across the cosmos than they are now. The same is true of everyone and everything around you, from this book in your hands to the uneaten cheese in your fridge and the noisy neighbor across the street. The same is also true of every lumpy asteroid, moon, and planet in the solar system, as well as the thermonuclear ball of the Sun itself.

All of us used to be strewn across the interstellar void. It is very likely that this is the first time that the specific atoms nestling in the 1.8-meter-long strand of DNA in any one of your cells have been this close together in the history of the universe.

So how did this come to be?

In simple terms, we all *condensed*. The fundamental physical properties of the universe conspired to pull together a set of atoms and molecules that previously had been occupying a volume a billion trillion times larger.

Because of their complex interactions (driven by gravity, electromagnetism, quantum mechanics, and subatomic physics), all those microscopic components found their way together to assemble themselves into a star, planets, moons, lumpy asteroids, noisy neighbors, cheese in the fridge, and you and this book.

This gathering of matter makes the scale at which we exist, and the scale of our planets and

Sun, somewhat special in the present-day universe. It's a physical range where coherent yet richly complicated structures form. It is also the scale in the universe at which four fundamental states of matter—solid, liquid, gas, and plasma—can coexist. And because of tinkering little humans, this is now a slice of the cosmos in which states have been created or reproduced that otherwise wouldn't exist in this milieu: ultra-high-energy states like quark-gluon plasmas in particle colliders, or super-low-energy states like Bose-Einstein condensates in laboratories, and low-temperature superfluids and superconductors, to name but a few.

States of Matter

The components of matter—ions, atoms, molecules—can organize and behave in different ways. We call these "states" (or phases) of matter. What happens at a microscopic level in matter often results in very different behavior at larger scales—from the solidity of ice or iron to the flow of a river to the outlandish behavior of a neutron star.

REGULAR STATES

SOLID
Components are closely packed and stay in fixed spatial relationships to one another—except for small thermal vibrations. Examples include ordered crystalline solids such as metals, diamonds, and ice. Non-classical solids include amorphous solids such as certain polymers, plastics, coal, and glass.

LIQUID
Components in close contact, but without a fixed order. Fluid can deform and flow.

EXOTIC STATES

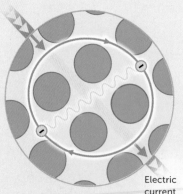

Electric current

Bose-Einstein Condensate
Cool objects such as helium atoms to nearly absolute zero and they can clump into a single quantum entity. Individual atoms lose their identity, becoming part of a "super-atom." Even photons can make a Bose-Einstein condensate, in the right conditions.

Superconductor
Cool an element such as niobium to 9.3 Kelvin and it becomes a superhighway for electrons, with zero electrical resistance. In a closed loop, electrons will circulate forever. Parts of neutron stars are expected to superconduct.

Superfluid
A liquid with no viscosity that slips past itself. Stir a superfluid and it will swirl forever. Superfluid chilled helium will also climb out of containers and escape through molecule-wide cracks. Related to Bose-Einstein condensation and superconductivity, superfluidity can exist in neutron stars.

THE CIRCLE OF ASTROPHYSICS

When our solar system condensed five billion years ago, it wasn't the first time such a thing had happened. The universe started out small, dense, hot, and expanding 13.8 billion years ago. It was also extremely uniform and boring, but not perfectly so. As a result, the bits of the cosmos with the most imperfections started pulling themselves out of the underlying cosmic expansion.

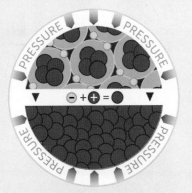

GAS
Compressible fluid of components moving freely, not in close contact. Gases have low viscosity and will expand to fill available spaces.

PLASMA
Shares properties with gases, but is electrically conductive due to charged components—ions surrounded by a sea of dissociated electrons.

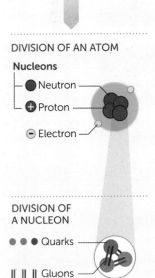

KEY: THE BUILDING BLOCKS OF MATTER

ATOM

DIVISION OF AN ATOM

Nucleons
- Neutron
- Proton
- Electron

DIVISION OF A NUCLEON

Quarks

Gluons

DEGENERATE MATTER
At extremely high densities or low temperatures, components of matter such as electrons can fill up all available quantum energy slots. A counterpressure called "degeneracy pressure" results. Degeneracy can occur for neutrons in neutron stars, preventing their collapse to black holes.

Quark-Gluon Plasma
Liquid-like soup of quarks and gluons, at temperatures of over a trillion degrees Kelvin. In the early universe and in particle accelerators, protons and neutrons can melt into this fluid. A QGP is a near frictionless liquid, but may be a gas at higher temperatures.

How do you get out of the expansion of the cosmos? Gravity. Some of these imperfections were places where the density of matter was a little higher than the surrounding average. Given a high enough density, self-gravity (a region's weight) would resist the expansion of space. That "self-pull" (a result of mass warping space-time around itself) was enough to overcome the underlying current of expansion and allow dark and normal matter to clump together.

But physics is tricky. As a gas of normal matter pulls together—or, rather, *falls* together—it transforms gravitational potential energy into thermal energy. In other words, it heats up. That sets in motion a competition between gravity working to condense matter and thermal-energy pressure spreading matter apart. In the right circumstances, though, if the matter can cool off fast enough, gravity can pull it into very dense concentrations indeed.

It's still a mystery what happened in that first hundred million years after the Big Bang, but it seems that a starter generation of very large stars and the beginnings of galactic structures were forming. These early stars were critical for generating the universe's first heavy elements, and for dumping them back out into interstellar space as the stars aged, inflated, and exploded.

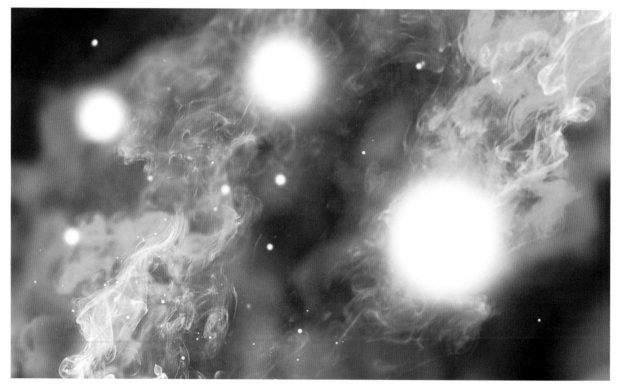

The first stars in the universe

Like a good feedstock for seedlings, that sprinkling of heavy elements opened up new channels for gas to cool—to lose the thermal energy that otherwise slows down new condensations and clumping. Subsequent generations of stars are far more varied in size as a result.

The violent endpoint of some stars as supernovas also triggers the speedy collapse of interstellar material that would otherwise teeter on the brink between condensation and dispersal. An exploding star sends relentless shock waves of gas and particles careening across interstellar space, setting off instabilities that lead to new condensations.

These early clumps of material pioneered a cycle of matter processing that has carried on ever since: Interstellar material gathered up, and some got dense enough to bind into stars (and planet-size bodies). Nuclear fusion in the hot cores of stars then built increasingly heavy elements. Anywhere from millions to billions of years later, those stars spewed a mix of elements back out into the void, usually leaving a stellar ember behind. Those embers are white dwarfs, neutron stars, or even black holes. These super-dense agglomerations are generally endpoints, places where matter is going to stay put for eternity (however long that really is).

Across billions of years, hundreds of billions of stars, and many of these cycles, interstellar space has gotten slowly polluted with these heavy elements. It's delicate pollution, though. Even now, only tiny amounts of these new elements exist compared to the bulk of hydrogen and helium that the universe started with. Elements like carbon, oxygen, nitrogen, silicon, and all the other heavy atoms around us account for barely more than a percent or two of normal matter. And these mostly exist in the sparse gas of interstellar or intergalactic space.

There is also a sprinkling of cosmic dust. This dust is microscopic, made of grains of silicates or carbon-rich compounds that are smaller than a tenth of a millionth of a meter across. These specks are the flash-frozen remnants of old stellar atmospheres and stellar guts, expelled by supernova explosions.

In the orbital swirl of a galaxy like the Milky Way, the densest accumulations of such star-stuff are visible in the nebulas: the molecular clouds that dot the galactic disk. There are many thousands of nebular regions. Parts of the largest—the Great Nebula—are actively condensing into new stars today, before the orbital drift of material in the galaxy and its gravitational jostling once again disperse these rather dirty nests.

We can reconstruct much of our solar system's *pre*-pre-history. Clues come from investigating the very distant cosmos, and the cosmos closer to home. We've also found critical insight

A star explodes.

by peering at microscopic remnants of this extraordinary past—the elements and radioisotopes embedded in ancient meteorites here on Earth.

All of which brings us to the bedtime story to end all bedtime stories.

PAST TO PRESENT

Once upon a time, over four and a half billion years ago, a modestly clumpy part of a rich nebula in the Milky Way galaxy began to slip inward and condense. In all likelihood it was tipped over its gravitational edge by the forces from a nearby stellar explosion. That's because in other parts of the nebula, the cycle of stellar birth and death was already far along. There was a litter of new stars and soon-to-be stars. And there were the more massive stars that had lived fast and died young, exploding as supernovas after racing through the chain of nuclear fusion processes that could occur in their cores.

Despite resistance from the pressure of gas in this clump, and the ethereal pressure of interstellar magnetic fields, gravity managed to prevail—causing more and more nebular material to fall together.

The physics of this condensation is rooted in laws like gravity, angular momentum, and thermodynamics but is simultaneously prone to nasty, messy, chaotic behaviors that cause many anxious moments for astrophysicists.

The shape and geometry that the matter takes on as it falls together is key. This mix of gas and dust concentrates in a growing central spherical core, it also flattens out into a giant orbiting disk. The disk is a varied, turbulent thing, puffed up toward its edges. Gas and dust spiral in through the disk, feeding the core. Fresh nebular material also feeds the disk from above and below in a great two-sided funnel that extends hundreds of times farther from the disk's center than Earth is from the Sun today.

The core is a fast-spinning globe of warming gas. Left to its own devices, this core would spin faster and faster while it grew, until it was disrupted. But in many cases, for a brief few tens of thousands of years, the combination of swirling influx and increasingly star-like core launches a fierce outflow of hot, accelerated matter from the new north and south poles of the central sphere.

Astronomers call this a proto-stellar jet—a beam-like torrent of particles that can race

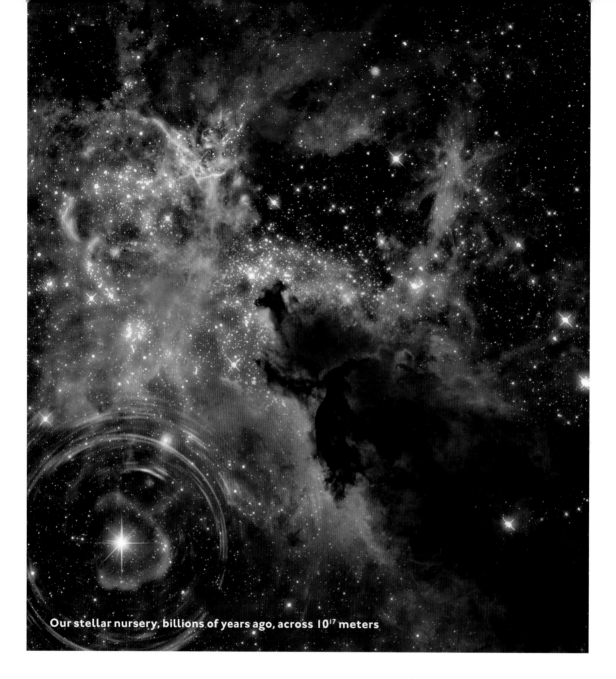

Our stellar nursery, billions of years ago, across 10^{17} meters

across spans reaching a light-year or more. These jets of matter plow into any nebula that's in the way, creating shock waves and glowing fronts of hot matter. This outflow helps regulate the core, bleeding off some of the angular momentum that would otherwise tear it apart, and allows it to shrink further and further.

All the while the great disk of surrounding material undergoes its own transformation. Deep

Our Sun today

10^{17}

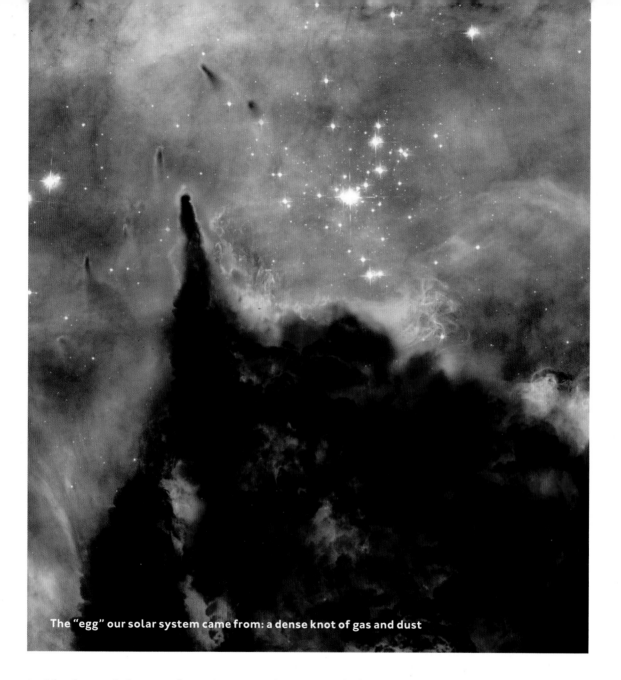

The "egg" our solar system came from: a dense knot of gas and dust

inside, beneath layers of varying temperatures and chemical composition, motes form that are made of dust and molecules. Microscopic at first, they are buffeted by the swirling gas. That buffeting can accelerate their growth as they sweep through more and more of their surroundings. These growing aggregates—sometimes like dust bunnies—reach scales of centimeters, meters, and larger. Some grow like a snowball rolling down a hillside. The bigger they get, the more mat-

Closer in to our Sun today

10¹⁶

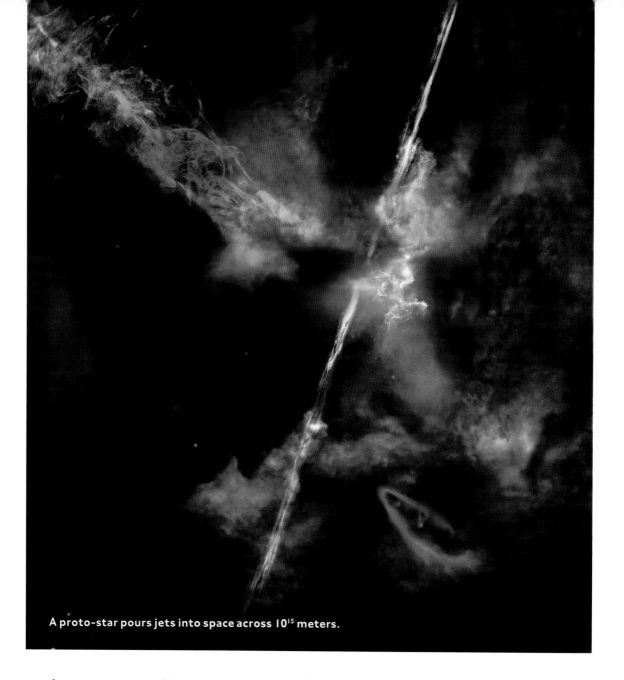

A proto-star pours jets into space across 10^{15} meters.

ter they sweep up, and in a runaway process they can grow to hundreds of kilometers across in a few tens of thousands of years. We call these planetesimals and proto-planets.

But time passes, and the exposed disk surfaces are blasted by ultraviolet light. That light comes from other young stars and from the hot central proto-stellar core. What it does is evaporate material away.

The modern-day Sun comes into view.

10^{15}

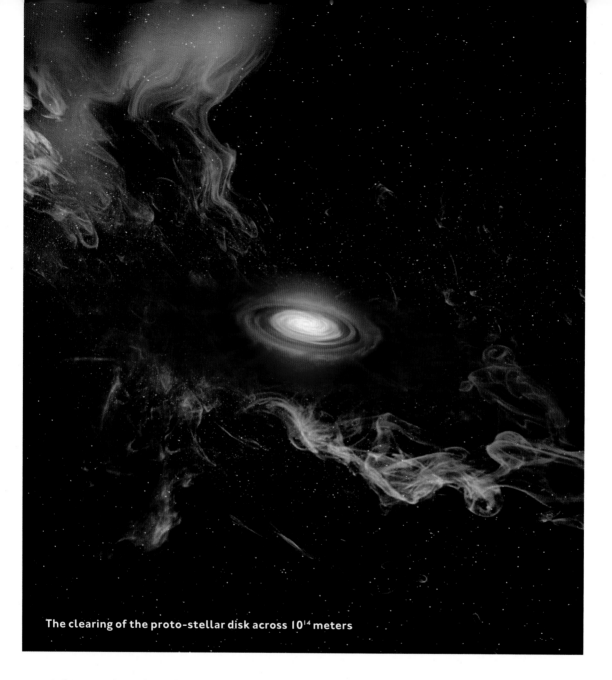

The clearing of the proto-stellar disk across 10^{14} meters

This combined agglomeration and loss of matter turns the great disk from a thick spread of gas and dust into a sparser collective of solid bodies and dissipating atoms and molecules. Well away from the proto-stellar core, in cooler zones, is a planetary snow line where water ice, a key building block for making giant objects, forms. Here we find the baby worlds of Jupiter, Saturn, Uranus, Neptune, and possibly other, later displaced, giant planetary embryos.

foreground asteroid remnant of planet formation

1014

Stars and planets condense out of interstellar space—when material collects and compacts itself. It's not an easy process. Gravity is pitted against thermal energy and electromagnetic energy, and no two systems are identical.

Proto-stellar jet High-speed outflow of hot, accelerated matter

The Trigger

Part of a great nebula becomes gravitationally unstable, possibly due to a passing supernova shock wave, and falls in on itself to form a disk of matter.

1 DARK CLOUD

Solar nebula contracts

200,000 AU

2 GRAVITATIONAL COLLAPSE

Time: 0

Star will be born in center

Planets will form in disk

10,000 AU

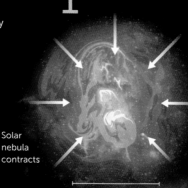

Warm temperatures allow only metal/rock material to condense in the inner system.

Proto-star
Gas and dust concentrate in a growing spherical region at the center.

Pure gas disk

Cold temperatures allow water ice, carbon dioxide ice, and more to form in outer system.

Distance to star (AU*)

0 AU 0.03 AU

Maker of Suns and Worlds

A proto-planetary disk is full of structure, flow, and activity. Its flared shape and luminous central star create zones of temperature, evaporation, and chemistry that influence composition and the growth of planetary building blocks.

3 PROTO-PLANETARY DISK

100,000 to 3 million years
Gas-and-dust structure may exist for as long as several million years.

Hot ionized region

Warm molecular region

Outer disk
(mass reservoir)

Cold midplane
(planet-forming region)

Dust inner rim

100 AU

10 AU

0.1 AU

Terrestrial planets form from metal and rock.

Planetary debris disk

Giant, mostly gaseous planets

Our Planetary System

Most gas is either evaporated or condensed into planets. Orbiting dust and solid chunks keep merging, colliding, and perturbing one another's motions. Planetary systems are always a work in progress.

4 GIANT PLANETS

3 to 50 million years

25 AU

5 YOUNG SOLAR SYSTEM

50 million years

25 AU

Solar wind helps blow remaining gas into interstellar space.

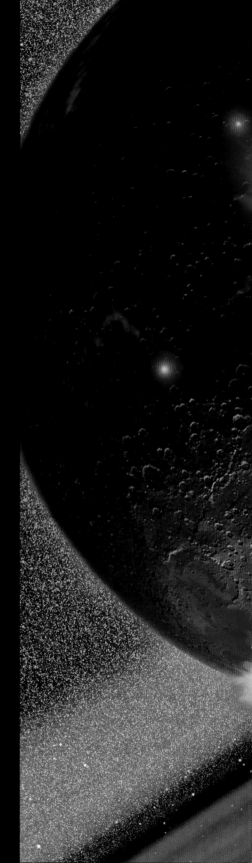

Simultaneously, down in the deep gravity well of the core, that spherical condensation of matter is reaching a critical point in its contraction. The inner temperature of this object is starting to edge above a million degrees Kelvin. When it hits ten million degrees it will become a true star, with the first flashes of nuclear fusion in its heart.

The amount of time that has passed since the drifting infall of nebular material is around a hundred million years. Even less time—about a hundred thousand years—has passed since this proto-star was simply a core of gas. By the standards of the cosmos, the birth of a star and its planets is pretty much an overnight affair.

We don't yet have the full story of the formation of the planets of our solar system, and of Earth itself. Our planet and the other rocky inner worlds emerge toward the end of the birthing process. And these objects get their final indelicate touches from great collisions in which proto-planets smack into proto-planets, again and again.

It's a rough, stochastic (randomly patterned) process that poses a multitude of still-unanswered questions: Did our solar system once have young planets within the orbit of Mercury? Where did Earth's water come from, and why are we not even wetter? How did Mars end up so small? Why are our planetary orbits comparatively circular? Did the Moon really form in a giant collision? What planetary bodies actually lurk in the outermost zones of the solar system?

If we can resolve questions like these, we'll not only better understand our origins, and the way in which we condensed from the universe, but we'll shed light on how a story like this can play out across trillions of other star systems. And that is key, because as our journey through scale continues, we are about to come right up against one of the biggest puzzles: the puzzle of us versus the cosmos.

Earth accreting from proto-planetary pieces

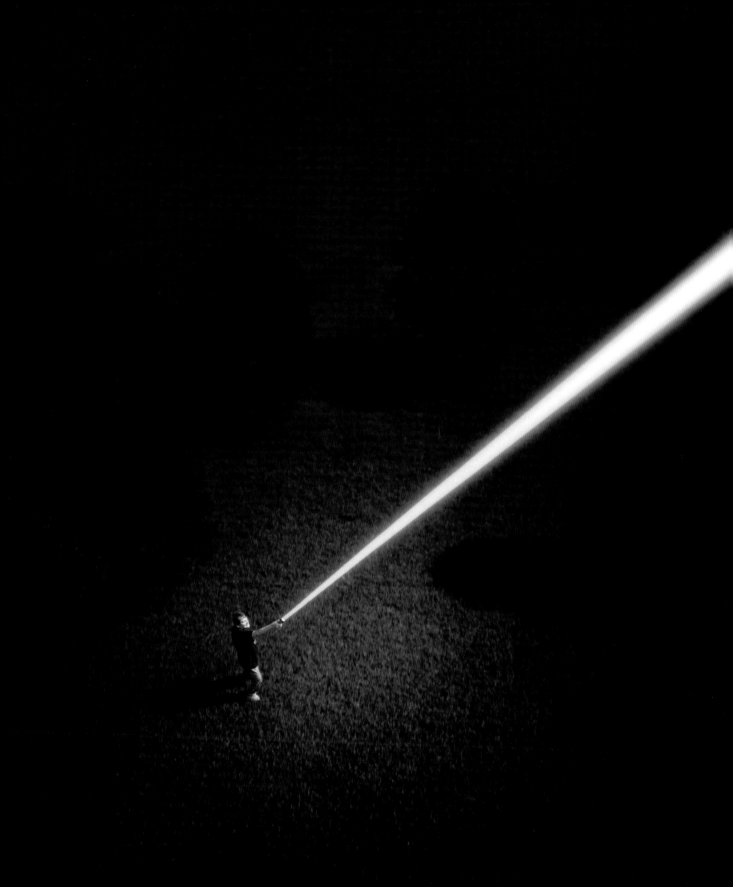

4

PLANETS, PLANETS, PLANETS

10^{13}, 10^{12}, 10^{11}, 10^{10}, 10^{9} meters

From about 9.3 light-hours to a million kilometers

From about twice the current Earth–Pluto distance to about three times the Earth–Moon distance

Go outside on a clear night and wave a flashlight at the sky. Then go and get a good night's sleep. The next morning, the photons you released into the universe will have traveled a distance of roughly ten billion kilometers (10^{13} meters).

With your flashlight and just over nine hours of peaceful dreaming, you've become a cosmic architect, sending out a photon-tipped yardstick that reaches past the orbital path of Neptune. Even infamous Pluto, that remote sphere of ice and rock, now lies more than two billion kilometers closer to us than the reach of your beamed photons.

Well within those 10^{13} meters is the orbital terrain occupied by the major planets of our solar system, all the worlds that we've spent thousands of years staring at from our hairy little primate heads. Our naked eyes can't see them all—Neptune and Uranus are beyond our unaided reach—but Jupiter, Saturn, Mars, Venus, and Mercury have always been visible to any terrestrial life-form with good enough eyesight, from bugs to baboons.

But just because our solar system's major planets orbit on these scales doesn't mean that other places are set up the same way. Across the galaxy, at these orbital separations we can also find stellar siblings: binary stars, triple star systems, quadruple star systems, stars paired with white dwarfs or black holes, neutron stars paired with neutron stars, and other exotic configurations. Even supermassive black holes' event horizons—the emperors of cosmic singularities—occupy this range of scales.

Neptune's orbit as seen from the Trans-Neptunian world Eris

10^{13}

Pluto's sky, with its moon Charon, and the Sun a dim star more than 4.4 billion kilometers away

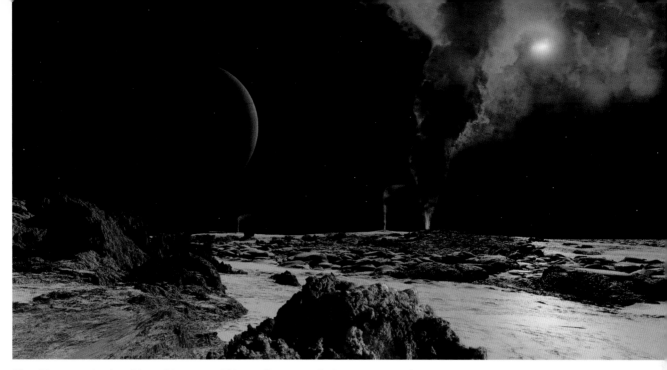

Blue Neptune in the skies of its moon Triton. Geysers of nitrogen erupt from the deep-frozen surface.

These are the scales that take us deep into the landscape of the densest condensations of normal matter and energy that the universe produces. And it's a weird landscape. We've already seen that although the interstellar muck that builds stars and planets starts out spread over 10^{13} to 10^{14} meters, by the time gravity has pulled those objects together and energy has dispersed the leftovers, what remains is largely empty space.

It is the planets that fill in the gaps, though—drops of iron, rock, water, and gas. And next to living things, planets may be the most diverse and complex objects in the universe. No two planets are identical: not in their orbital paths through space nor in their rotations and orientations, their atmospheres, clouds, hazes, layers, seas or continents, or soupy molten innards. All these properties are invariably variable.

And now, thanks to a series of extraordinary technological and astronomical advances beginning in the late twentieth century, we know that there are at least as many planets as stars in our galaxy, and probably in the universe as a whole. In fact, there are likely many more. The cosmos is teeming with exoplanets.

And when it comes to places that could resemble Earth in size, and possibly in chemical and thermal states as well, our statistical extrapolations tell us that between 15 percent and 40 per-

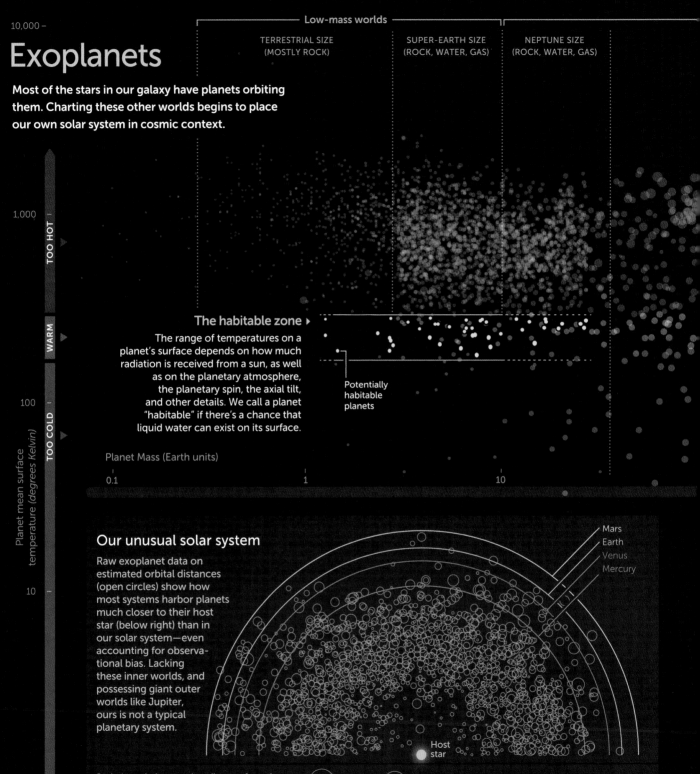

Exoplanets

Most of the stars in our galaxy have planets orbiting them. Charting these other worlds begins to place our own solar system in cosmic context.

TERRESTRIAL SIZE
(MOSTLY ROCK)

SUPER-EARTH SIZE
(ROCK, WATER, GAS)

NEPTUNE SIZE
(ROCK, WATER, GAS)

10,000 –

1,000

100

10

1

TOO HOT

WARM

TOO COLD

Planet mean surface temperature *(degrees Kelvin)*

The habitable zone ▸

The range of temperatures on a planet's surface depends on how much radiation is received from a sun, as well as on the planetary atmosphere, the planetary spin, the axial tilt, and other details. We call a planet "habitable" if there's a chance that liquid water can exist on its surface.

Potentially habitable planets

Planet Mass (Earth units)

0.1 1 10

Our unusual solar system

Raw exoplanet data on estimated orbital distances (open circles) show how most systems harbor planets much closer to their host star (below right) than in our solar system—even accounting for observational bias. Lacking these inner worlds, and possessing giant outer worlds like Jupiter, ours is not a typical planetary system.

Mars
Earth
Venus
Mercury

Host star

Scaled to relative star size; distance from the center plotted on a logarithmic scale

◯ Jupiter ◯ Saturn ◯ Neptune · Earth · Mercury

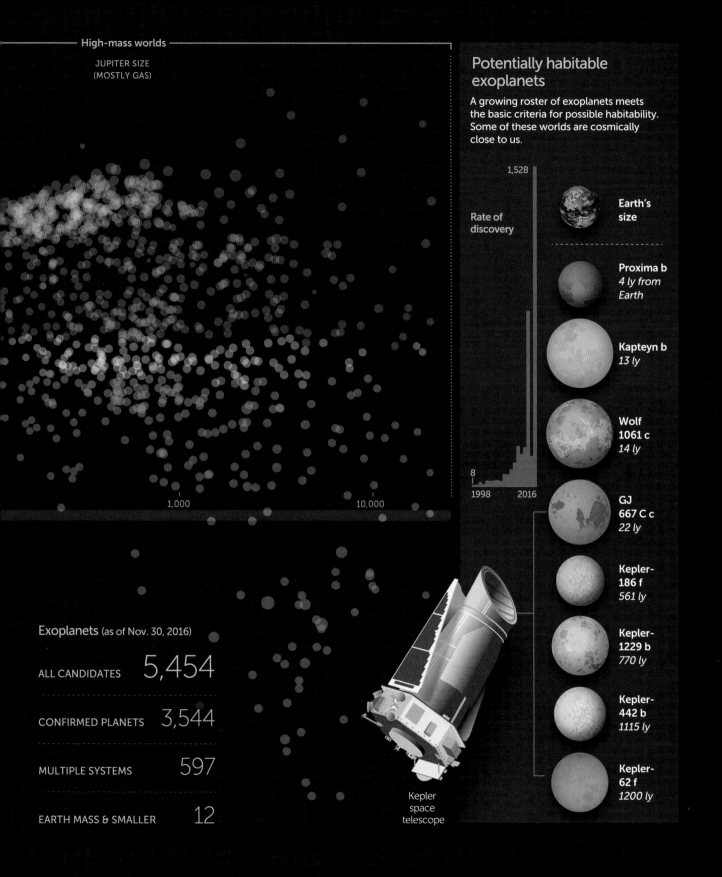

High-mass worlds

JUPITER SIZE
(MOSTLY GAS)

1,000 10,000

Potentially habitable exoplanets

A growing roster of exoplanets meets the basic criteria for possible habitability. Some of these worlds are cosmically close to us.

Rate of discovery

1,528

8

1998 2016

Earth's size

Proxima b
4 ly from Earth

Kapteyn b
13 ly

Wolf 1061 c
14 ly

GJ 667 C c
22 ly

Kepler-186 f
561 ly

Kepler-1229 b
770 ly

Kepler-442 b
1115 ly

Kepler-62 f
1200 ly

Exoplanets (as of Nov. 30, 2016)

ALL CANDIDATES 5,454

CONFIRMED PLANETS 3,544

MULTIPLE SYSTEMS 597

EARTH MASS & SMALLER 12

Kepler space telescope

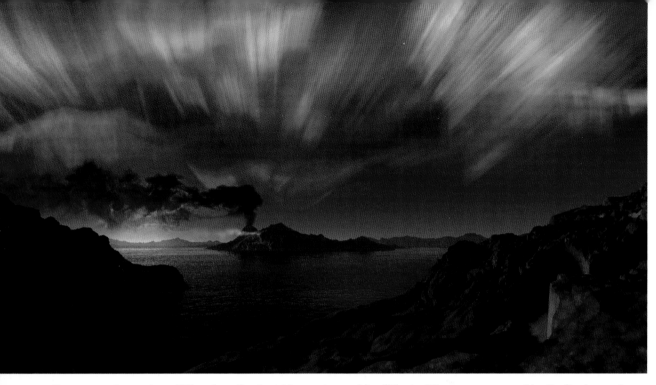

Our nearest exoplanet? Proxima Centauri b may have skies filled with auroras caused by its flaring red-dwarf sun.

cent of stars play host to such worlds outside our solar system. That's an astonishing projection to make. It means that across the entire observable cosmos, there could easily be a *billion trillion* of these potentially life-friendly rocky globes.

Despite that abundance, small rocky planets represent just one of the many possible variations of the planetary form. There are other planets almost large enough to be stars, and there are worlds that are themselves the satellites of other worlds. There are even worlds that have been gravitationally ejected from orbiting their birth stars to wander the frigid backwaters of interstellar space. These "Steppenwolf" planets could conceivably maintain warm oceans of water, snugly trapped and insulated inside a thick outer ice crust and hydrogen atmosphere—interior oases lasting for billions of years after their formation.

There are plenty of gas giants, some with dense iron and rock cores enveloped in massive cloaks of primordial hydrogen and helium. Planets like these can be chilly on the outside, orbiting billions of kilometers from their star, but fiercely hot on the inside. Their internal pressure must also result in states of matter that are quite alien to us feeble surface dwellers. Pressures inside a gas giant like Jupiter are so extreme that hydrogen can become metallic—a state of mat-

A Planet Taxonomy

The composition and internal structure of planets are diverse. Gravity acts to segregate and layer components inside all larger worlds, and cosmic environments modify exteriors. From hot to cold, the planetary zoo is full of species.

HOT SATURN (PUFFY PLANET)

SIZE: **VERY LARGE**
EXAMPLE: **HAT-P-1b**

Extremely low density. Atmosphere inflated by stellar radiation and magnetic-field heating.

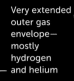
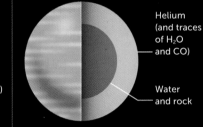

Very extended outer gas envelope— mostly hydrogen and helium

Metallic hydrogen

Iron-rich core

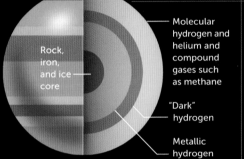

Molecular hydrogen and helium and compound gases such as methane

Rock, iron, and ice core

"Dark" hydrogen

Metallic hydrogen

GAS GIANT

SIZE: **LARGE** EXAMPLE: **JUPITER**

Interior still poorly understood. Central pressure and temperature over 40 million atmospheres and 40,000 Kelvin.

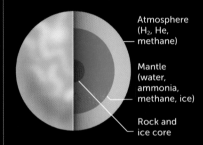

Atmosphere (H_2, He, methane)

Mantle (water, ammonia, methane, ice)

Rock and ice core

ICE GIANT

SIZE: **MEDIUM LARGE** EXAMPLE: **NEPTUNE**

The prototype, Neptune, is 17 times the mass of Earth and nearly 4 times the radius.

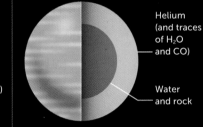

Helium (and traces of H_2O and CO)

Water and rock

HELIUM PLANET / WARM NEPTUNE

SIZE: **MEDIUM LARGE** EXAMPLE: **GJ 436b**

Possibly formed by the evaporation of hydrogen from ice giants that orbit close to their parent stars.

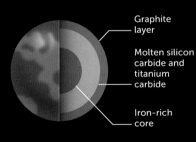

Graphite layer

Molten silicon carbide and titanium carbide

Iron-rich core

CARBON PLANET

SIZE: **MEDIUM** EXAMPLE: **55 CANCRI e**

May form in carbon-rich, oxygen-poor proto-planetary disks. Could contain diamond layers.

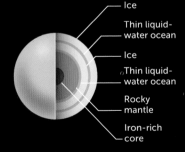

Ice

Thin liquid-water ocean

Ice

Thin liquid-water ocean

Rocky mantle

Iron-rich core

ICE PLANET / MOON

SIZE: **MEDIUM SMALL** EXAMPLE: **GANYMEDE**

Thick frozen water shell may contain liquid oceans in one or more layers. Oceans warmed by rocky core and tides.

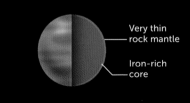

Very thin rock mantle

Iron-rich core

IRON PLANET

SIZE: **SMALL** EXAMPLE: **KEPLER-10b**

Could originally be rocky planets, later stripped by asteroid impacts. Likely to cool rapidly.

Auroras glow across a terrestrial-type world orbiting a flaring star.

ter we can barely reproduce in our laboratories, yet one that makes up the greatest fraction of planetary mass in our solar system.

Across the galaxy a small fraction of giant planets also closely orbit their stars, their atmospheres literally white-hot, with clouds and rain of titanium oxides or iron, bands of supersonic jet streams, and hellishly extreme weather. How these worlds came to be is still somewhat mysterious. Planets of this size—hundreds of times the mass of Earth—simply can't form where we find them. In other words, they have changed location, undergoing a grand form of migration, coerced to come close to their parent stars by the complex gravitational pulls of the protoplanetary disk during childhood. Or they've played planetary pinball, jostling with the gravity of the other planets in their family and getting scattered into orbits close to the star.

Elsewhere there are ice giants with layers of steel-like frozen water and hydrocarbon-laced atmospheres. We suspect that there are worlds fantastically rich in carbon, or water. And there are super-Earths—worlds larger than Earth but smaller than Neptune—that have no counter-

part in our own solar system, yet orbit about 60 percent of all other stars. Some of these appear to be radically different from any rocky world we are familiar with, such as molten-magma planets encased in great warm blankets of hydrogen gas.

As we chart these new exoplanets and explore our own solar system, we're upending our preconceptions about Earth's monopoly as "most important world." Everywhere we look, and everywhere we go, we see signs of activity and complexity. Saturn's moon Titan has a thick nitrogen and hydrocarbon atmosphere. While its surface may be a frigid 93 Kelvin on average, Titan nonetheless has seasons. It has summers and winters across its hemispheres, and great cycles of evaporation and condensation that can dry up the moon's lakes of methane and then rain that hydrocarbon back out. Remote Pluto has a rich landscape of mountains, glaciers, and cryovolcanic change across its frozen surface.

A ROAD ALMOST TAKEN

Most of the planets we study are following paths through the curved space-time of Einstein's relativistic universe—inside the gravity wells of their stellar parents. For our species these planetary orbits are among the most iconic features of the cosmos, yet in truth they are products of our imagination. They are extrapolations and geometric fantasies that help us get a grip on nature's complexity.

An orbit is really an approximation, an averaging over time of the motion of stars or planets. Real systems are complicated landscapes of gravitational attractions. Stars pull on stars, planets pull on planets. Planets hang on to moons, and moons pull at one another. At any instant, the forces acting on objects are a summation of all these pulls—the collective action of the many on one.

As a result, planetary systems are chaotic at heart, and over millions and billions of years there can be orbital creep—a phenomenon known as chaotic diffusion. This creep is inherently unpredictable in its details, but we can anticipate what different timelines might look like. Tiny changes in planetary positions or speeds, even a few millimeters here or there, can lead to very different futures a billion years hence. Even the effects of Einstein's relativity—although subtle at typical planetary speeds and masses—help determine these cosmic histories, because they modify the behavior of moving worlds.

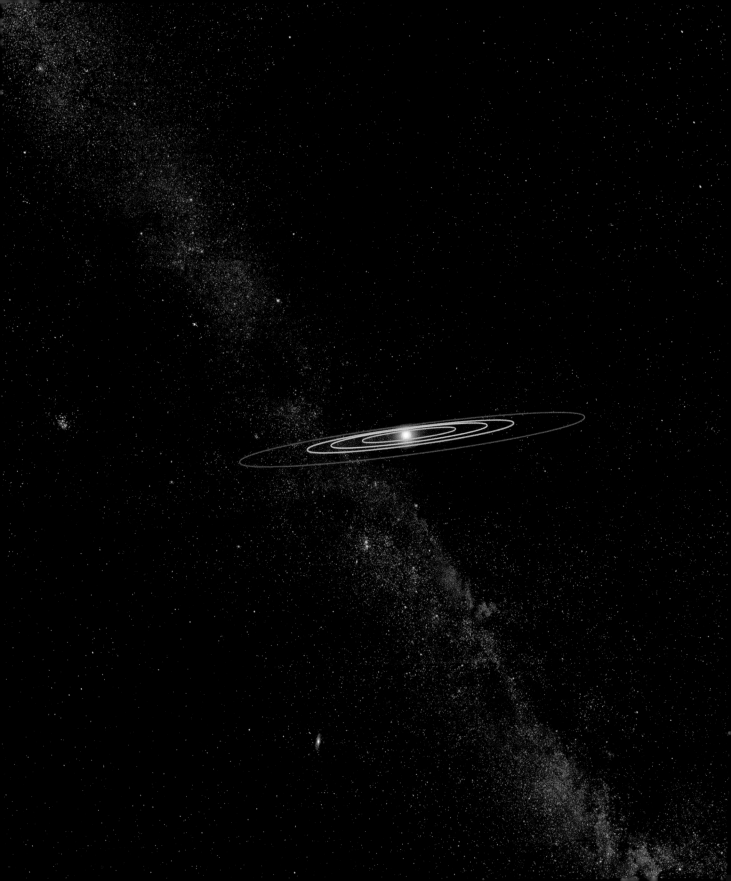

10^{12}

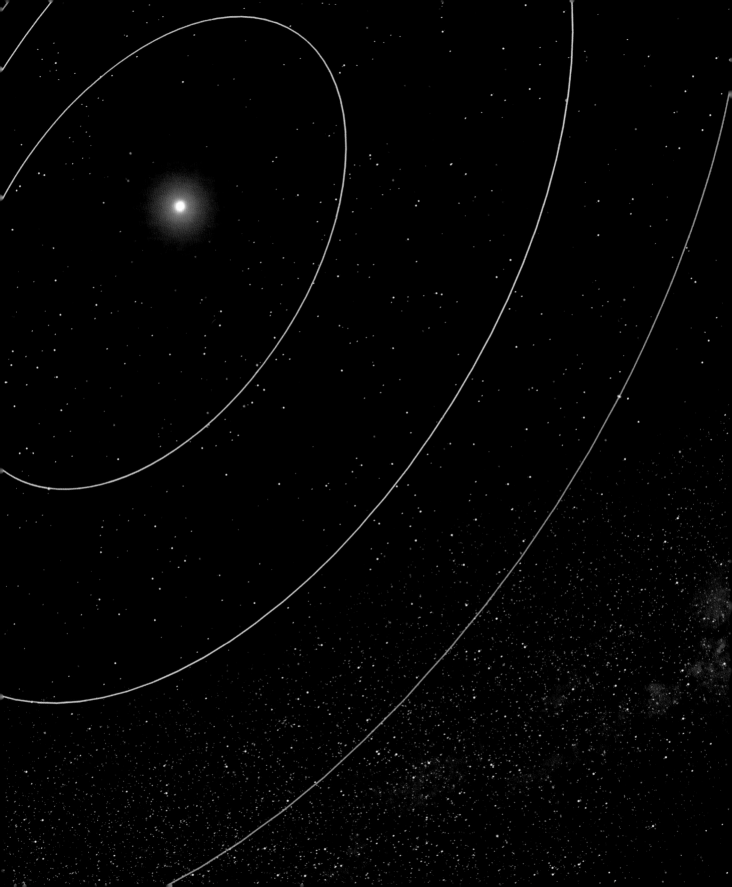

The orbits (left to right) of Mercury, Venus, Earth, and Mars

10^{11}

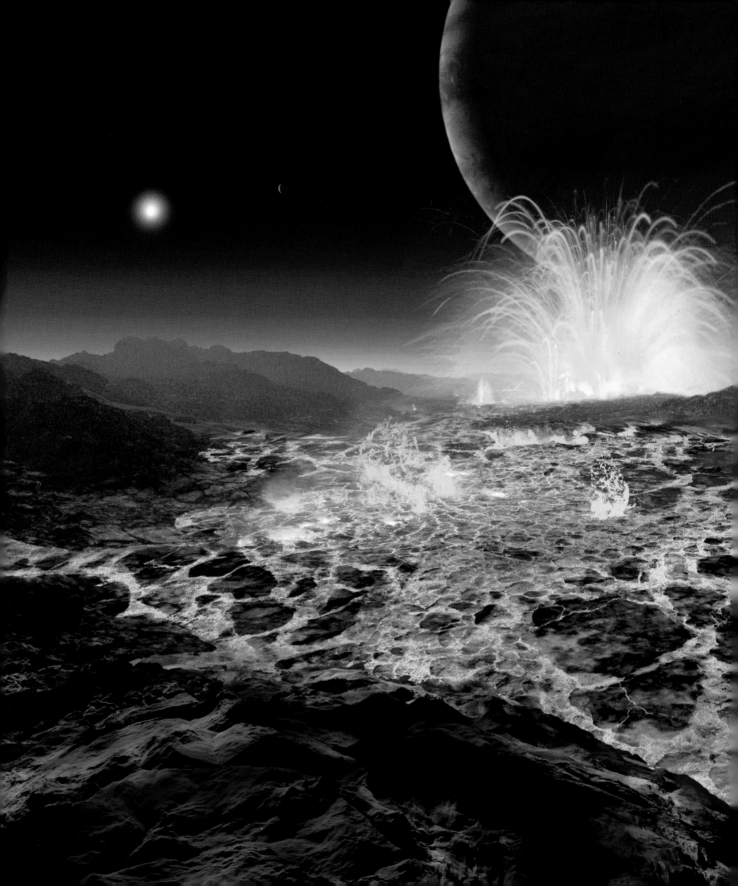

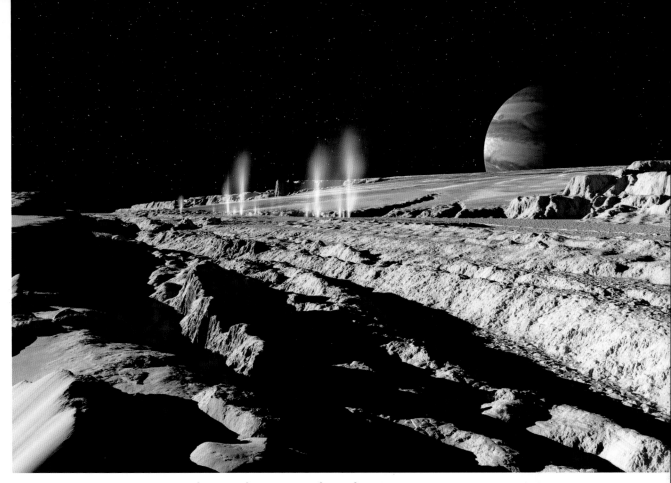

Fire and ice: The Jovian moons Io (*opposite*) and Europa (*above*) both experience gravitational tides.

Tidal forces also play a critical role in the story of planets. These are differential pulls, exerting force unevenly on "near" and "far" sides of the same body as a consequence of gravity's dependence on distance—the inverse-square law. Over time, tides can turn elliptical orbits into circular orbits, by bleeding off the energy of motion and converting it into the frictional heat of a planetary interior.

Tides have sculpted much of our own solar system's detail. The lockstep motion of many moons—in which their rotation period is matched to their orbital period—is a product of tides. The hot volcanoes of Io, and the cryovolcanism of Enceladus, Triton, and ancient Pluto, together with the suspected dark interior oceans of Europa, Ganymede, Titan, and many more bodies, are largely the result of tidal forces.

The track of Earth's orbit and the loop of the Moon's orbit

10¹⁰

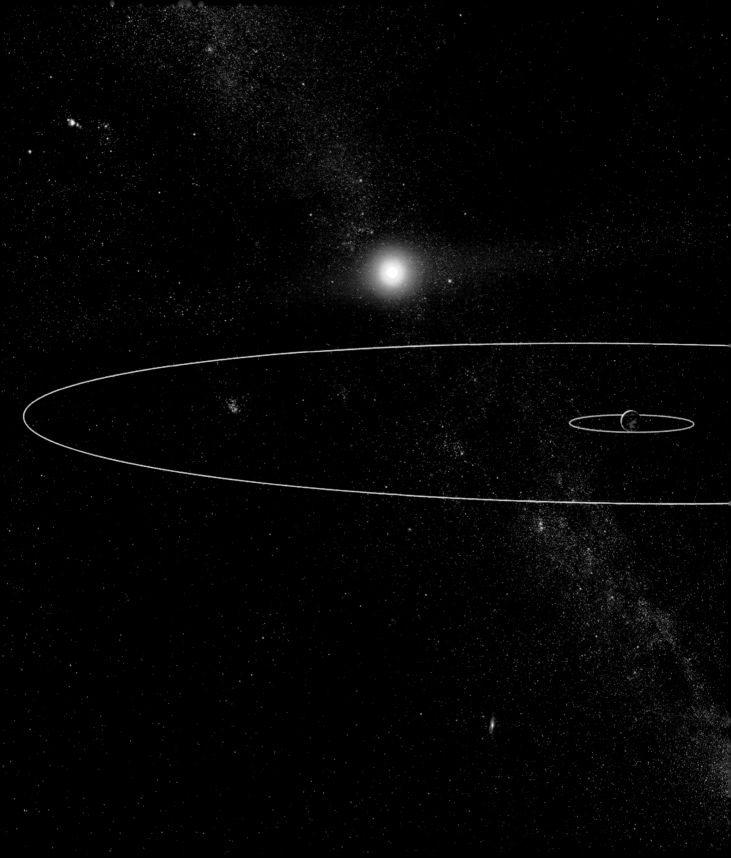

10⁹

Earth seen from the Moon during a lunar eclipse

And as our journey of scale brings us to our own Moon, our dark, dusty, gray companion, we find that it's been trapped and coerced by tides into its present configuration, still evolving as its orbit recedes a few centimeters a year and Earth gradually slows its own spinning.

These changes go back a long way. The record of Earth's ocean tides, seen in sandstone rocks that were coastal beaches 620 million years ago, suggests that back then Earth had a roughly twenty-two-hour day. Combined with our best bet for how the Moon formed—from a massive collision between an earlier version of Earth and a Mars-size proto-planet—we can guess that a young Earth, four and a half billion years ago, spun fast and had a far shorter day. The ocean tides, generated as Earth spun ahead of the Moon's orbital circuit, would have been huge. Billions of years later those sloshing mounds of water and the kneading of rocky mantles have still not dissipated all the momentum of that original agitated system.

That's a happy thing, because those tides are some of the tangible links that exist between our daily experience and the dynamics of our place in the universe. You were able to use your flashlight to send a probe into the cosmos because you live on a planet molded by these forces. Earth's present conditions have created opportunity for organisms like us to exist, and the same conditions provide clues to decoding how we came to be.

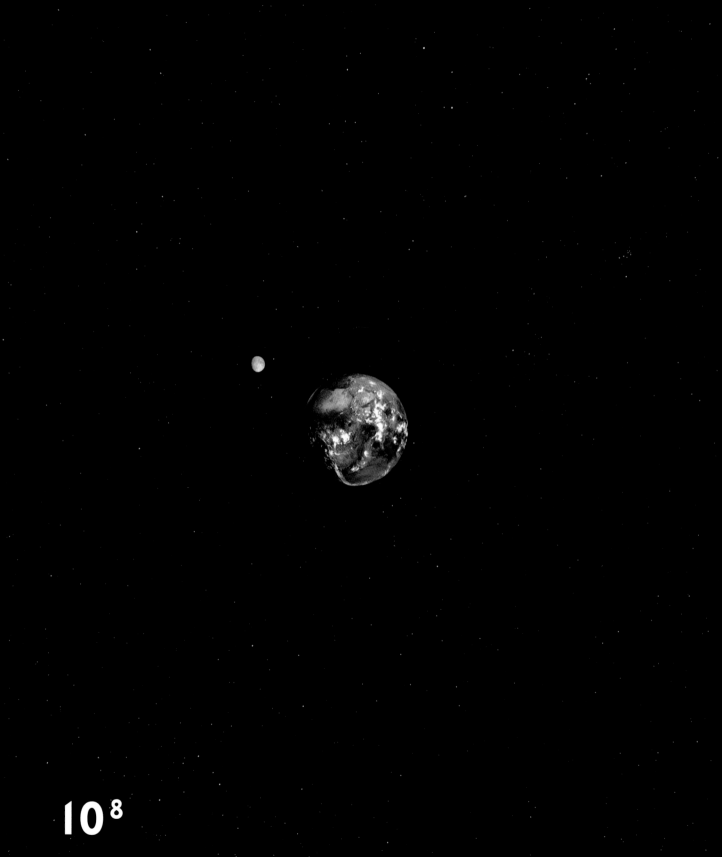

10⁸

5

A WORLD WE CALL EARTH

10^8, 10^7, 10^6, 10^5, 10^4 meters

From 100,000 kilometers to 10 kilometers

From about 26 percent of the Earth–Moon distance to the height of Mauna Kea from the ocean floor

What is Earth?

The answer depends on whom you ask. For a planetary scientist or a geophysicist, Earth is a deep sphere of iron, blanketed by a droplet of hot rock, topped off by a thin crust of crystallized minerals. For an astronomer, Earth is a minuscule condensation of star-stuff, the heavy-element detritus from very-long-dead previous generations of stellar objects. For a number-crunching statistician, Earth is one data point out of a trillion trillion worlds in the observable universe. It is a modest and slowly evolving outlier in the landscape of planets.

For biologists, Earth has been the incubator for the dynamic phenomenon we call life for nearly all of its existence. During that long passage of time, the face of this world has changed and changed again. Earth has transformed from a fearsome magma ocean to a wet ball of rock, and back and forth from a global hothouse to a global freezer with all shades of climate in between. Sometimes its crinkled surfaces have swarmed with living things. Sometimes it has been nearly barren after colossal extinction events have eliminated entire families of organisms.

Earth is also a mixture of the very old and the very young. The most ancient surface rocks you can hold in your hands have been dated to an age of over 3.5 billion years. Dense little crystals of zircon that you can find in igneous rocks like granite have been dated to an astonishing 4.4 billion years. Despite this age, the planet is active: it still builds new volcanic islands, its deep dynamo

drives a strong dipolar magnetic field, and its surface niches still evolve new species of organisms. In these ways Earth is a world where no one instant truly represents its full history or future.

But for you and me, beyond these colorful scientific waypoints, what matters most of all is that Earth is an indelible part of our being.

Earth evokes a wealth of sights, sounds, smells, and tastes: It's the first time you feel the ground beneath your feet, or the soft ocean waves rolling over your floating body. It's your experience of the Sun rising over the horizon in the serene morning mist. It's the potent odor of soil and plant life after a summer rainstorm. For some of us, it's the thrill we feel with the gentle brightening of stars in a blackening evening sky. Earth is also a restless and sometimes treacherous home for us. This is a planet whose winds can buffet us, a world where blizzards and typhoons beat us down and the ground itself can shake us to bits.

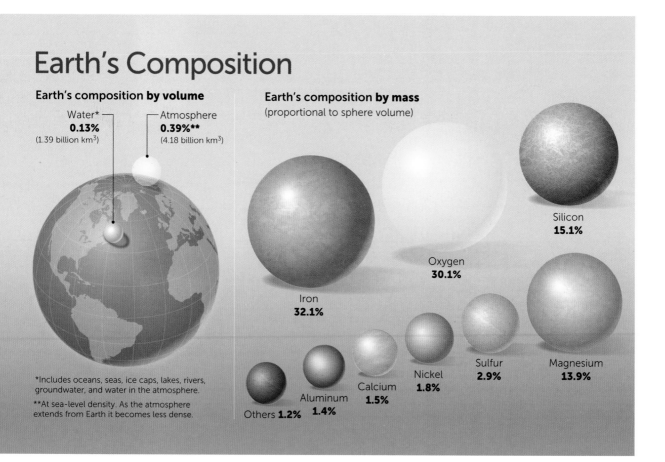

Earth's Composition

Earth's composition by volume

Water*
0.13%
(1.39 billion km³)

Atmosphere
0.39%**
(4.18 billion km³)

*Includes oceans, seas, ice caps, lakes, rivers, groundwater, and water in the atmosphere.

**At sea-level density. As the atmosphere extends from Earth it becomes less dense.

Earth's composition by mass
(proportional to sphere volume)

Silicon
15.1%

Oxygen
30.1%

Iron
32.1%

Magnesium
13.9%

Sulfur
2.9%

Nickel
1.8%

Calcium
1.5%

Aluminum
1.4%

Others **1.2%**

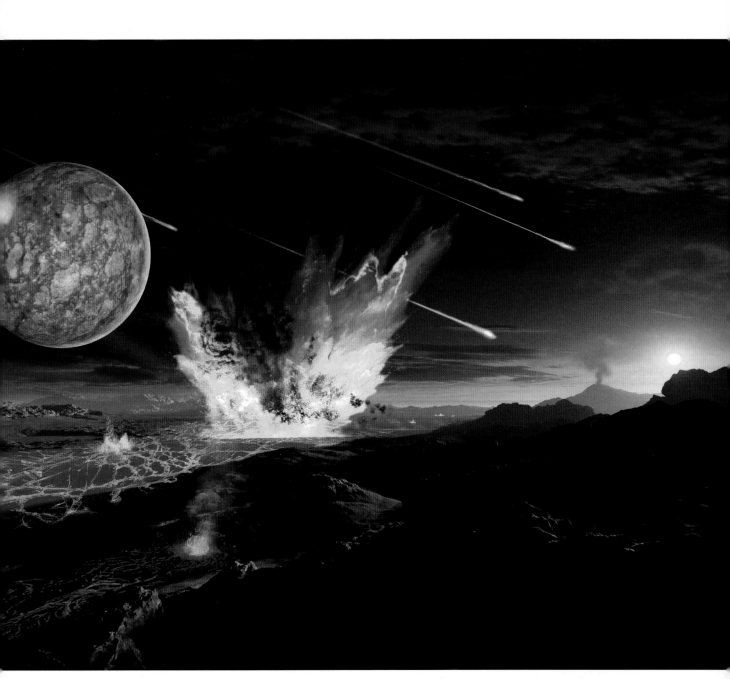

Earth's deep history, from the Hadean eon (over 4 billion years ago) to the Phanerozoic eon (541 million years ago until now). (*Above*) The Hadean eon, starting 4.6 billion years ago. (*Following spread*) The start of the Archean eon, 4 billion years ago (top left); early microbial life builds stromatolites, 3 billion years ago (bottom left); global glaciation, a "snowball Earth" around 2.4 billion years ago (top right); the lush Jurassic Earth, 150 million years ago (bottom right)

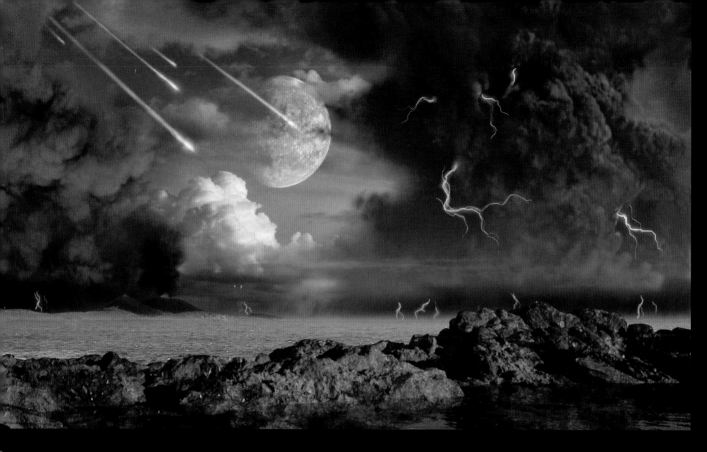

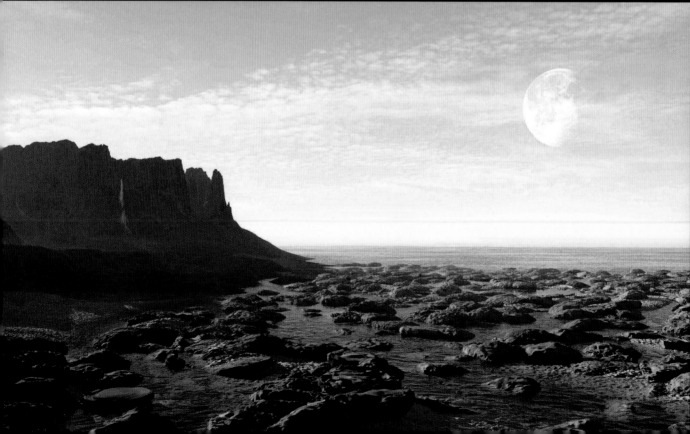

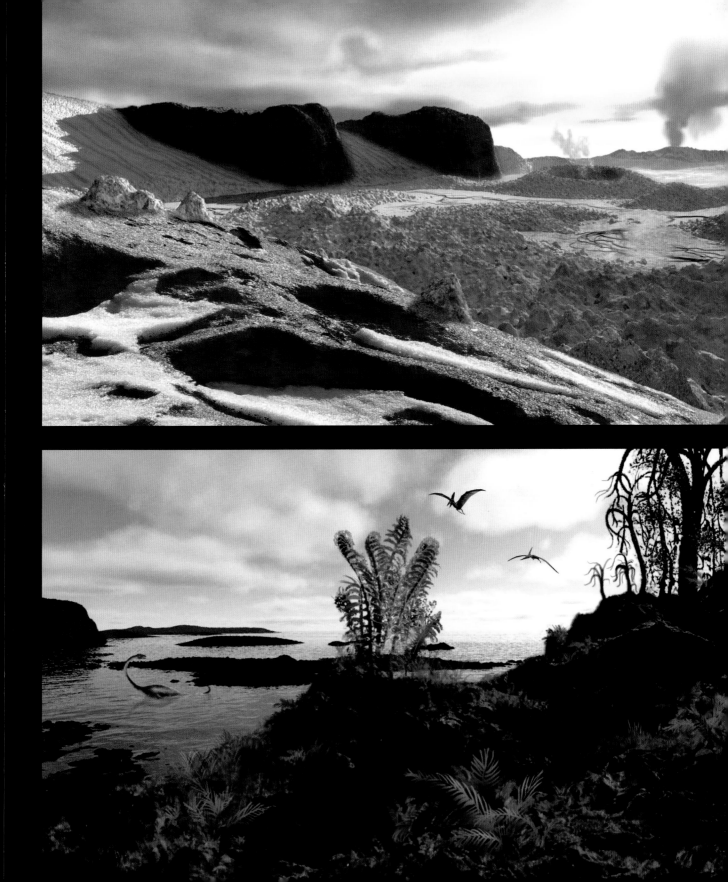

Exploring a volcanic mid-ocean ridge. A scientific gold mine, but also a worryingly tempting place to exploit for mineral resources

We dig into this world with our hands, and mine it with our tools. We mold its substances into forms that we need, or simply want. Like all living things, we are constantly converting one set of compounds into another, in the air we breathe, the food we eat, and the fuels we burn. Billion-year-old bedrock becomes building material for a home, a school, or a statue. Seams of naturally concentrated metals become our bridges, cars, bicycles, wedding rings, and circuit boards. Refined ores become fuel for nuclear reactors; arduously extracted rare-earth elements help guide electrons and enhance magnets in computers and smartphones.

We've become expert at this scavenging—too expert for our own good. We've drastically altered the balance of the Earth, and as a consequence now exert enormous pressure on organisms and environments that are part of the very system that supports us.

Of course, we're not the first species to mess around with the global environment. About two and a half billion years ago, species of microbial life began to dump their waste product, oxygen, into the atmosphere. That chemical pollution signaled a profound shift in the chemical and climatological state of the planet, and in all the life that followed.

Those early photosynthesizing oxygen producers had little choice in the matter—they were simply deploying the metabolic tools that emerged from their evolution. We humans are distinct, and interesting, because we are aware of what we're doing and usually have some sense of the consequences of our actions.

By the same measure, while Earth is our birthplace and playpen, it's also completely indifferent to us. There is no special reason why Earth is "just right" for us. After all, we came from *it*—not the other way around. Whatever we do to the Earth, and whatever we do to life here, the planet will carry on and evolution will keep unfolding, relegating our era to a thin band in some future sedimentary rock.

That's because (like any planet) Earth is a powerful thermodynamic, chemical, and radiological machine. Multitudes of phenomena are knit into the planetary surface and interior, as well as woven through time. Properties that we take for granted, from climate to fossil fuels, are the consequence of deep cycles and serendipitous events scattered across billions of years. In truth, all that we relish about Earth is one sentence of a much larger story.

ABSORB, CHURN, RADIATE

The connected processes of our planet start revealing themselves as our cosmic journey brings us into familiar territory. As we hover near the 42,000-kilometer altitude of a geosynchronous orbit above the Earth, we get to see an almost complete hemisphere. Visible across this side of the world are some of the primary engines of a rocky planet—the forces that drive the thermal and environmental state of its surface.

On the daytime side of Earth, the solar radiation hitting the top of the atmosphere deposits around 1,300 watts of power per square meter. That's about the same amount used by an electric kettle. It doesn't seem like a great deal.

But add up that incoming solar radiation across one whole hemisphere of the Earth, and a total of about 174 *petawatts* (10^{15}, or a quadrillion, watts) of solar power is hitting the top of the atmosphere. A colossal total of 89 petawatts of that same power is absorbed by the surface of the Earth directly. The rest is reflected by the surface, or absorbed by the atmosphere and reflected by its clouds of condensed water.

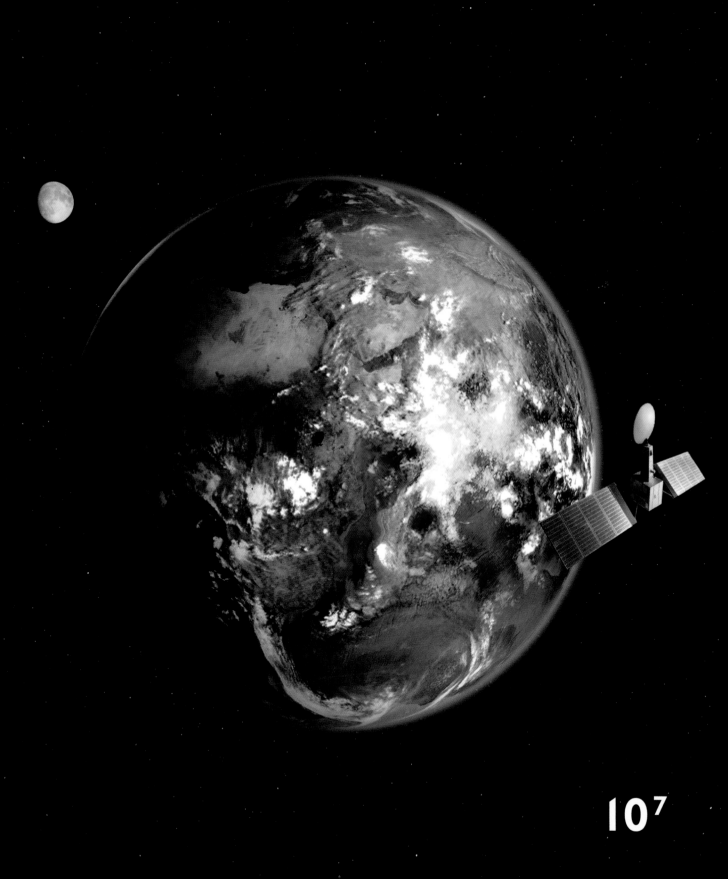

10^7

The top of Earth's atmosphere receives a barrage of solar photons.

By human standards this is a fearsome amount of energy. Estimates of current human energy consumption suggest that in a single year we use roughly 1.6×10^{11} megawatt-hours, which means that with 8,760 hours in a year we are using energy at a rate of about 0.018 petawatts. *All* life on Earth (adding up photosynthetic organisms, water transpiration in plants, and what life gets from chemical and geophysical energy) is estimated to consume energy at a rate of between 0.1 and 5 petawatts. In other words, despite life's potent footprint on the planet, on a cosmic scale it's still barely sipping at what the Sun's photons rain down on us.

The native heat of Earth—from its still-molten interior—is also modest in comparison. All geothermal and geochemical power flowing through the planet's surface adds up to about 0.047 petawatts.

The gloriously bright daytime side of the Earth is therefore not just a pretty sight. It signals a relentless absorption of electromagnetic radiation. Earth reflects, but it also acts like a giant sponge for photons that would otherwise streak off into the rest of the cosmos. We may be a small world, but we cast a long shadow.

But where does that power go? As with any material object, Earth's tendency is to constantly lose any excess energy—to reach equilibrium with the surrounding universe. Except it's coated with atmosphere and oceans that slow down the loss of energy. The planet heats up as a consequence, promoting the shedding of infrared photons into space to redress the imbalance. But much of the energy has to pass through other forms and intermediate steps before escaping. It drives the movement of the atmosphere and oceans and both their chemistries, transforming this planet into an engine of novelty.

We can easily see some of these energy-reprocessing machines in action. Across the Earth we can watch flows of atmosphere and ocean spanning thousands of kilometers. The spinning planet pulls these fluid materials around with it—one gas, one liquid. But solar energy interferes on a grand scale. For example, warm, moist air rises from the equator and tropics, lofting to altitudes of ten to fifteen kilometers before turning north and south. Eventually that air falls at

mid-latitudes, creating a planet-spanning north-and-south torus of atmospheric flow. Similar flows exist toward the poles, with different mechanisms at play.

Because air is transported away from the equator, where it is moving the fastest with the spinning planet, its rotation gets out of sync. As a result the atmosphere experiences the Coriolis effect, causing it to move toward the east relative to Earth's surface.

As a consequence of this shift, high-speed flows of atmosphere called jet streams (both subtropical and polar) form at altitudes of around ten kilometers and can encircle the planet. If you've ever flown between North America and Europe, you've probably experienced a jet stream that speeds your journey west to east, but slows your return east to west as a headwind.

Jet streams also help divide Earth's atmosphere, separating cool and warm air. But if a high-latitude jet stream weakens or meanders, frigid air can descend on lower latitudes—causing trouble and grumbling for humans who are in the way.

Yet, in a universe filled with planets, Earth exhibits only modest examples of these phenomena. Elsewhere in our solar system, the gas giant Jupiter spins once every ten hours and has multiple atmospheric jets, writ large as great bands of color wrapping the planet. Saturn, appearing so calm and regal, actually has a polar vortex of atmosphere at its north and south ends, and equatorial high-altitude wind speeds that reach a brisk 1,800 kilometers an hour.

Another consequence of the turbulent behavior of Earth's solar-driven atmosphere is weather. The most spectacular examples are spawned by the low-pressure regions where massive amounts of warm, moist air loft into the sky: the tropical storms, whether called hurricanes, cyclones, or typhoons, that roll across the planet.

These rotating beasts give us a glimpse of the sheer power being pumped into the planet. As water evaporates from an ocean and re-condenses in a hurricane-forming region, it releases an enormous amount of thermal energy. By many estimates, one day of a single large hurricane involves *200 times* as much power as the world's total electrical production capacity.

Earth doesn't just get hot and bothered by solar energy; its chemistry is changed. For the past 4.5 billion years ultraviolet light from the Sun has helped break apart stratospheric molecules including water and oxygen, driving vigorous photochemistry in Earth's atmosphere. Sunlight has also persistently beaten down on surface minerals, inducing chemical and structural changes. And, of course, via the catalytic processes of life, especially photosynthesis, solar energy has affected profound chemical alteration. Some changes take a single day, as a bloom of

10^6

Earth's Machinery

Like any object, Earth absorbs and dissipates energy, seeking to maintain thermodynamic equilibrium with its surroundings. But as energy flows, it drives complex, planet-spanning phenomena.

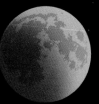

THE MOON

Drives tides in Earth's oceans and atmosphere. Together with solar tides, it pumps an additional 3 terawatts of power into the planet.

EARTH'S MAGNETIC FIELD

This dipolar field interacts with the solar wind's charged particles. Electrical currents are driven into Earth's atmosphere and conductive rocks.

ATMOSPHERIC CIRCULATION

With an equatorial rotation velocity of 1,700 km/h and latitude-dependent solar heating, the Earth drives large vertical and horizontal movements in its fluid-like atmosphere. These transport energy around the planet.

CIRCULATION PATTERNS

Polar cell

Ferrel cell

Hadley cell

NORMAL POLAR JET STREAM

H

ABNORMALLY COLD

L

WEAKENED POLAR JET STREAM/VORTEX

SUBTROPICAL JET STREAM

30° N

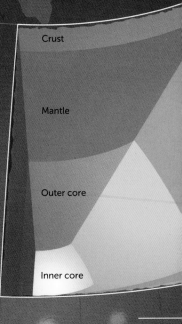

INSIDE THE EARTH

The crust
Outer rocky shell, 3 to 120 kilometers thick.

The mantle
Mostly solid but hot, from 500°C at crust to over 4,000°C near core.

The core
Solid iron-nickel inner core is surrounded by liquid-metal outer core whose movements generate Earth's magnetic field.

Crust

Mantle

Outer core

Inner core

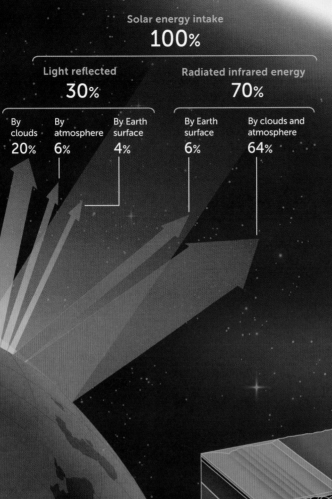

Solar energy intake
100%

Light reflected			Radiated infrared energy	
30%			**70%**	
By clouds	By atmosphere	By Earth surface	By Earth surface	By clouds and atmosphere
20%	**6%**	**4%**	**6%**	**64%**

THE SUN'S POWER

Solar radiation ranges from gamma rays to visible light to radio waves. Total solar irradiance, a measure of total power added over all wavelengths, peaks in visible light. Altogether, Earth receives only 1/10,000,000 of the Sun's total power output.

VOLCANOES AND EARTHQUAKES

Earth is geophysically active. Altogether, about 47 terawatts of power at the planetary surface come from geothermal and geochemical processes.

Rising magma

Downgoing oceanic plate

HURRICANES AND TYPHOONS

Warm, evaporating ocean water heats the atmosphere when it condenses—driving large low-pressure systems with circulating winds. Energy release rates can hit a petawatt.

Hot air Cold air

In the eye of the storm: A meteorological plane ventures across the eyewall of a hurricane.

algae grows in shallow marine environments. Others play out over centuries, as tree roots break ground, or acidic wash from microorganisms alters the rocks and minerals of Earth's surface.

HEAD IN THE STARS

From the scale of Earth's globe to a patch of ten thousand meters, this is a world of texture, dynamism, and variety driven by energy. This planet is the most meaningful connection most of us have to the cosmos. Yet, since the rise of modern humans, most of us could easily go a lifetime without moving more than a short distance above Earth's surface. That's still true, with a few special exceptions.

Since the 1960s more than 530 humans have spent time in space, either lobbed into suborbital flight or zipping around in Earth orbit. On nine occasions we've gone on the long haul to and from the Moon, setting foot on it six times. As much as these experiences have showcased our technical prowess, they've also brought us a profoundly different view of our world than was afforded any of the billions of biologically modern humans that came before.

These lucky astronauts, cosmonauts, and taikonauts have found themselves in awe of what they've seen. Here is Earth in some of their words:

I think the one overwhelming emotion that we had was when we saw the Earth rising in the distance over the lunar landscape. . . . It makes us realize that we all do exist on one small globe. For from 230,000 miles away it really is a small planet.
—Frank Borman, *Apollo 8*, press reports, January 10, 1969

The Earth was small, light blue, and so touchingly alone, our home that must be defended like a holy relic. The Earth was absolutely round. I believe I never knew what the word "round" meant until I saw Earth from space. —Aleksei Leonov, USSR

My first view—a panorama of brilliant deep blue ocean, shot with shades of green and gray and white—was of atolls and clouds. Close to the window I could see that this Pacific scene in motion was rimmed by the great curved limb of the Earth. It had a

Earth's varied hues, viewed from above Lake Turkana, in northern Kenya and Ethiopia

10⁵

thin halo of blue held close, and beyond, black space. I held my breath, but something was missing—I felt strangely unfulfilled. Here was a tremendous visual spectacle, but viewed in silence. There was no grand musical accompaniment; no triumphant, inspired sonata or symphony. Each one of us must write the music of this sphere for ourselves.

—Charles Walker, USA

We learned a lot about the Moon, but what we really learned was about the Earth. The fact that just from the distance of the Moon you can put your thumb up and you can hide the Earth behind your thumb. Everything that you've ever known, your loved ones, your business, the problems of the Earth itself—all behind your thumb. And how insignificant we really all are, but then how fortunate we are to have this body and to be able to enjoy living here amongst the beauty of the Earth itself.

—Jim Lovell, *Apollo 8* and *13* astronaut, interview for
the 2007 movie *In the Shadow of the Moon*

A Chinese tale tells of some men sent to harm a young girl who, upon seeing her beauty, become her protectors rather than her violators. That's how I felt seeing the Earth for the first time. I could not help but love and cherish her.

—Taylor Wang, China/USA

Above Kenya, the first small signs of human existence

10⁴

10³

6

BEING CONSCIOUS IN THE COSMOS

10^3, 10^2, 10, 1, 10^{-1} meters

From 1 kilometer to 10 centimeters

From the length of an easy walk to the approximate size of your hand

So far, we've gone from scales where entire galaxies are like glinting motes of dust to scales where whole planets are mere droplets of solidified minerals. Now we've arrived at a scale where *we* are the motes scattered across the world. It's taken about twenty-four orders of magnitude to get here.

From inside the membranes of our multicellular motes of mostly water, we spend our lives looking, listening, smelling, and feeling. Somehow we construct meaning out of those senses. We have that slippery property we call consciousness, and we also have that faculty we label intelligence.

It may be that other complex life across the cosmos is built the same way. We simply don't know yet whether or not that is the case. Perhaps our biology is not the only way to construct living things. We also don't know if human intelligence is a good example of how intelligence works everywhere—or, for that matter, what we really mean by intelligence. It could simply be the ability to solve mazes or open cans of food. Or it might be better gauged by the capacity to perform mathematical proofs and figure out the nature and origins of the universe.

Consciousness makes these conundrums even trickier. For thousands of years philosophers, scientists, poets, and artists have driven themselves crazy trying to figure out what consciousness is. Many modern neuroscientists would say that consciousness is our brain's way of integrating information, of assembling a coherent model of the world as fed through our senses. But that

As we come closer, the signs of complex life begin to pepper Earth's landscape.

also means that consciousness is more than the sum of its parts. Consciousness may be a new and irreducible state built from the electrochemical gunk in our brains.

Altogether our situation is a bit farcical. We're in a horrendously unsuitable place for gaining objective truths about the nature of reality: inside a singular, self-aware mote of flesh drifting through space and time. And yet, it is precisely that aspect of our nature that compels us to ask all these awkward questions. It's easy to argue that this very act of self-examination needs to be examined.

That's nasty. It's like trying to write a piece of computer code that interprets and debugs itself, or asking an artist to paint a picture of what it's like to paint a picture. That's also a challenge in our journey through all physical scales of existence. All we can really do is home in on one small rocky planet that orbits one ordinary star out of a trillion trillion stars in the observable universe and cross our fingers that this helps us disentangle the phenomenon of life.

To cap it all, life's basic forms can be deceptive. Very little is as it first appears to our eyes.

For example, an octopus is not just an octopus; it is tightly linked to other organisms and embedded in a web of biological evolution across epic timescales. Even its body is a landscape where trillions of smaller entities play out their Darwinian battles.

At an even more fundamental level, all life as we know it appears to be the emergent product of the interaction of mind-numbingly large numbers of tiny, repeated, varied, and recombined structures. As we'll see, these molecular building blocks are the direct result of the physics of protons, neutrons, electrons, and electromagnetic forces.

Such tiny components simply follow the fundamental "rules" of the universe that were locked into place some 13.8 billion years ago. Yet, in concert, they can build galaxies, stars, planets, elephants, humans, birds, bugs, and who-knows-what-else across the cosmos.

How does this happen? That question sits at the absolute core of scientific and philosophical inquiry, at the heart of our efforts to construct a rational picture of nature from our inconvenient vantage point. The answer is a work in progress.

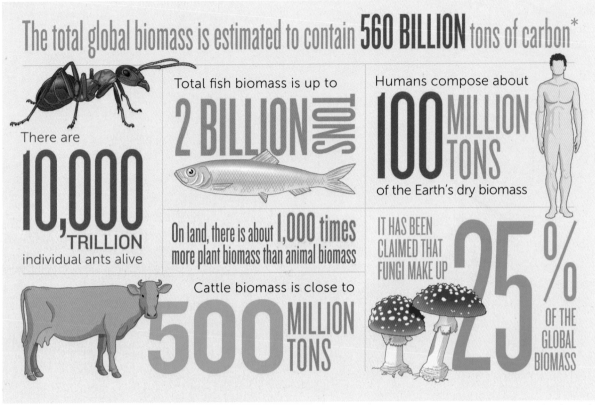

The total global biomass is estimated to contain **560 BILLION** tons of carbon*

There are

10,000
TRILLION
individual ants alive

Total fish biomass is up to

2 BILLION TONS

On land, there is about **1,000** times more plant biomass than animal biomass

Cattle biomass is close to

500 MILLION TONS

Humans compose about

100 MILLION TONS

of the Earth's dry biomass

IT HAS BEEN CLAIMED THAT FUNGI MAKE UP

25%
OF THE GLOBAL BIOMASS

* Not counting bacteria

LIFE ON THE CRUST

Part of our progress on these tough questions about existence comes from better quantifying our home in the universe. That process starts simply enough. For example, 70 percent of Earth's crusty exterior is covered in liquid water. That zone represents a great, and greatly varied, habitat. It is filled with life on all scales, from microscopic single cells to some of the largest individual multicellular organisms that currently exist on this world.

The hugely diverse dry land masses represent another set of habitats altogether, almost a parallel dimension to the oceans. Here life has had an opportunity to play out differently, even though the same underlying set of rules applies. These landscapes range from jungles to deserts, massive glacial ice caps to tropical islands, and mountains to plains.

For humans, one of the most intriguing spots when it comes to disentangling our journey from our origins lies in the Great African Rift Valley. This area is part of an extraordinary geo-

Two sentient species inspect each other: humans in jeeps, elephants in their herd.

10²

graphic trench. It's a place where plates of planetary crust are literally pulling apart, fracturing a band of brittle minerals into a diverse patina.

In eastern Africa, from Eritrea to Mozambique, this massive tectonic system—more than 6,000 kilometers in length—has caused an array of oversize geographic features, including stratovolcanoes, notably Mount Kilimanjaro, which rises almost 5,900 meters above sea level; dropped valleys with sides as high as 600 meters; and deep, fjord-like bodies of water. Lake Victoria, the world's largest tropical lake, with nearly 70,000 square kilometers of tropical freshwater, helps feed the present-day Nile.

Within the Rift Valley we've discovered tangible clues to our own beginnings: the fossil remains of early species of humans, which have helped us write and rewrite our prehistory.

One of these species, known as *Homo habilis*, likely existed between 2.8 million and 1.5 million years ago. Another is *Homo erectus*, first appearing about 1.9 million years ago. Other proto-human fossils have been assigned distinct labels too, but the truth is that we don't yet have a complete picture of who was loping around millions of years ago, and how they were all related. We also don't really know how widespread these hominid species were, but it's likely that their extent was regional rather than continental.

LOOK WHO'S WATCHING

Despite the long occupancy by strains of upright hominids, today there are still large areas of the Rift Valley where the flora and fauna are relatively unscathed by modern human standards.

In Kenya, for example, our journey through the scales of nature can bring us in just a couple of zooms from the hard vacuum of space to hover above a herd of elephants. They're inspecting, and being inspected by, a small herd of nervous humans in their metal jeeps.

A few more twists of the telephoto lens bring us in on an individual pachyderm. And on an oxpecker bird sitting on that elephant and prying loose a juicy louse from folds of tough skin.

Taken in a larger context, this tableau is particularly intriguing. Here is a giant mammal, a 4,000- to 7,000-kilogram mass of multicellular life. It incubates its offspring in an internal womb and has glands that dispense nutritious milk to them for at least five years after birth. An elephant's brain is a massive net of some 300 billion neurons (more than three times as many as a human's).

10

These creatures show complicated, and apparently altruistic, social behavior. They are almost certainly conscious. They are clearly intelligent, even if their smarts are not exactly like ours.

At the same time, the elephant's feathery symbiotic companion has a different lineage, one that had a last common ancestor with mammals 300 million years ago. The oxpecker, like all modern birds, is a descendant of a particular group of "great lizards"—the egg-laying dinosaurs. Between 65 million and 260 million years ago, the oxpecker's raptor ancestors scooted about this very same continental landscape. It was a world where dinosaurs had the evolutionary upper hand, or at least hogged the evolutionary limelight.

The oxpecker is certainly aware and intelligent by standards that we recognize. Many birds show signs of self-awareness, numeracy, and tool use. Yet a bird's brain is physically much smaller than that of either the elephant or a human, and contains (only) about 100 million neurons.

Role reversal: Once, some dinosaurs succeeded as apex species, while mammals did not.

The parasitic louse in the bird's beak has an ancestry that goes even further into the past. It is part of the group of wingless insects, at least 480 million years old, that evolved from a group of invertebrates. In that sense the louse is the most alien organism in the picture, and also the most successful, despite its present predicament.

Is the louse conscious or intelligent? Some insects, like bees, show behaviors that can be construed as signs of cognition, of intelligence, and can have upwards of a million neural cells. The louse is no bee, but we don't know what's really going on in its nervous system.

This one brief slice of life (a snapshot out of hundreds of millions of years of photo opportunities) contains another critical story.

A mammal hosts a bird and an insect. The bird consumes the parasitic insect, helping the

Brains of the World

Brains are built out of neurons—specialized cells that form electrically sensitive networks capable of receiving, processing, and transmitting electrochemical signals. Brains are the most complex biological structures we know of.

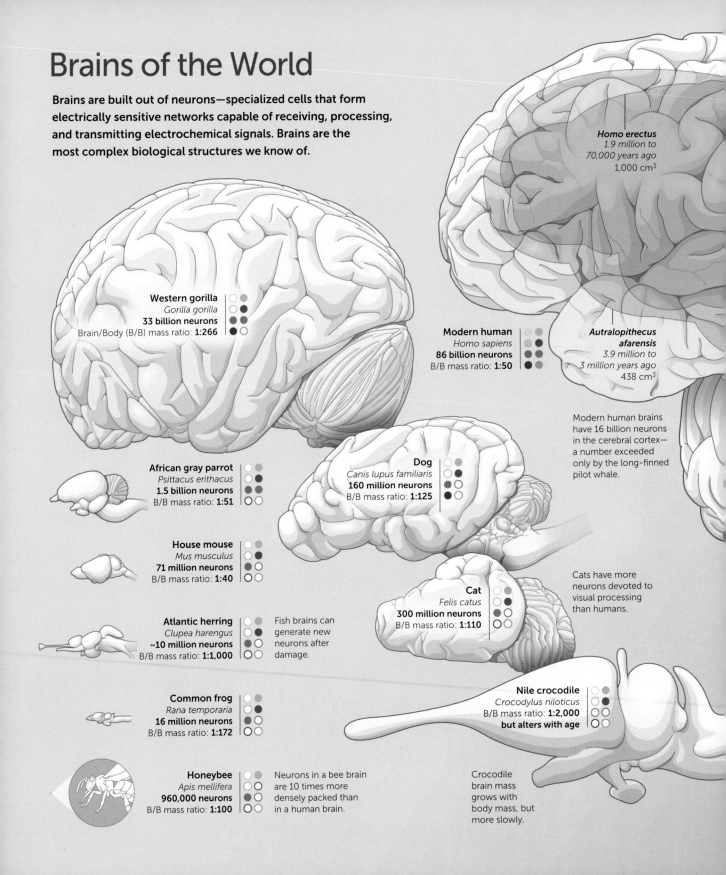

Homo erectus
1.9 million to 70,000 years ago
1,000 cm³

Western gorilla
Gorilla gorilla
33 billion neurons
Brain/Body (B/B) mass ratio: **1:266**

Modern human
Homo sapiens
86 billion neurons
B/B mass ratio: **1:50**

Autralopithecus afarensis
3.9 million to 3 million years ago
438 cm³

Modern human brains have 16 billion neurons in the cerebral cortex—a number exceeded only by the long-finned pilot whale.

African gray parrot
Psittacus erithacus
1.5 billion neurons
B/B mass ratio: **1:51**

Dog
Canis lupus familiaris
160 million neurons
B/B mass ratio: **1:125**

House mouse
Mus musculus
71 million neurons
B/B mass ratio: **1:40**

Atlantic herring
Clupea harengus
~10 million neurons
B/B mass ratio: **1:1,000**

Fish brains can generate new neurons after damage.

Cat
Felis catus
300 million neurons
B/B mass ratio: **1:110**

Cats have more neurons devoted to visual processing than humans.

Common frog
Rana temporaria
16 million neurons
B/B mass ratio: **1:172**

Nile crocodile
Crocodylus niloticus
B/B mass ratio: **1:2,000**
but alters with age

Honeybee
Apis mellifera
960,000 neurons
B/B mass ratio: **1:100**

Neurons in a bee brain are 10 times more densely packed than in a human brain.

Crocodile brain mass grows with body mass, but more slowly.

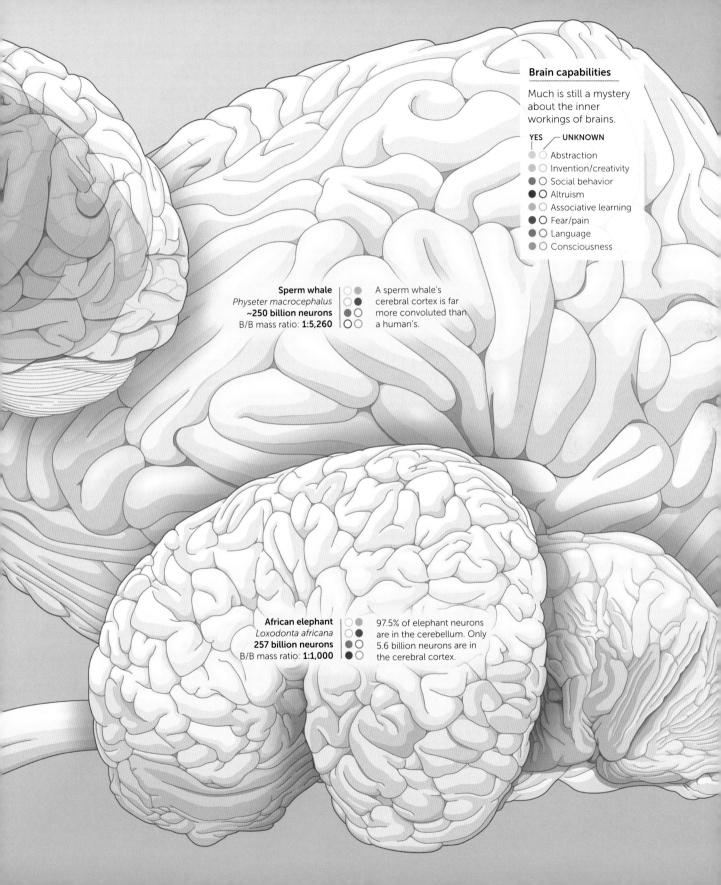

Brain capabilities

Much is still a mystery about the inner workings of brains.

YES — UNKNOWN

- Abstraction
- Invention/creativity
- Social behavior
- Altruism
- Associative learning
- Fear/pain
- Language
- Consciousness

Sperm whale
Physeter macrocephalus
~250 billion neurons
B/B mass ratio: **1:5,260**

A sperm whale's cerebral cortex is far more convoluted than a human's.

African elephant
Loxodonta africana
257 billion neurons
B/B mass ratio: **1:1,000**

97.5% of elephant neurons are in the cerebellum. Only 5.6 billion neurons are in the cerebral cortex.

mammal. The bird also feeds itself, and inadvertently contributes to variations in the genetic future of lice, since the unlucky louse's lousy descendants will no longer exist. If *this* bird hadn't sat on *this* elephant, and found *this* louse, a complex chain of future events would have turned out differently. In some futures this single event won't matter. But in others it could, in principle, snowball to alter the entire evolutionary trajectory of life on Earth.

Chaos-inducing contingencies in history like these are only the tip of the iceberg. Elephants constantly alter the larger environment around themselves. They eat vegetation, they drink water, they move and disturb soil and rocks. In effect they promote external entropy, the quantifiable disorder of the universe. Plants and other organisms in this same environment feel the pressure of these changes, and natural selection (survival of the fittest), along with genetic drift (survival of the luckiest), causes biological change across all timescales.

The oxpecker does the same thing. It nests; it drops waste; it competes with other birds, with other organisms. And the louse, equal parts lowly and mighty, plays its role too. It is part of the community of lice, and it is an excellent home to the bacteria and viruses it carries through the ecosystem.

As we zoom into this seemingly innocuous snapshot of life in the Rift Valley, we're catching a glimpse of what makes a true planetary biosphere—a staggeringly complicated, layered, and interlaced hierarchy of atoms, molecules, life, planets, stars, and cosmic thermodynamics.

Those curious phenomena we call consciousness and intelligence are slid into the interstices of this system. We don't know whether complex life always has to evolve such characteristics to better survive, or whether these are oddities confined to life on Earth. We don't know precisely how consciousness and intelligence scale from lice to elephants and beyond. But the actions of us humans can propagate far, far into the future, and far into the universe. Intelligence allows us to decide on those actions. The real question is how we choose to deal with such a capacity.

10⁻¹

10⁻²

7

FROM MANY TO ONE

10^{-2}, 10^{-3}, 10^{-4}, 10^{-5} **meters**

From 1 centimeter to 10 micrometers

From the size of a human fingertip to the size of a cloud-water droplet or an animal cell

The planet we call home is fading into the background as we zoom ever further down the cosmic scale. All of Earth's color and drama is now just a blur that's a billion times larger than the scope of our new waypoint. But this scale and the next few orders of magnitude within it are far from boring. You're going to be challenged here by concepts that are both beautiful and strange. The first of these is what we call complexity.

Complexity is a central part of the currency of the universe. We've already encountered it out among the galaxies and nebulas, but it infuses our daily existence too. The very structure of our bodies and the multilayered populations of species that we live with are proof of that. Although we seldom notice, we live in a world of complicated biological granularity.

The built-in limitations of our senses don't let us quite see this world for what it really is. If we hold two tiny objects at a comfortable distance from our faces, our eyes can only distinguish, or resolve, the pair if they're separated by at least the width of a human hair. Cut that separation in half, and even the most eagle-eyed of us can't tell whether we're looking at one or two objects.

Because of this limitation, we've spent most of the past hundred thousand years painfully unaware of the universe beneath our noses, under our fingernails, in our blood, drool, and skin. We've mostly thought about our physical selves, and other creatures, as tightly wrapped packages. Everything from great beasts to lowly bugs appears equally solid and self-contained.

But all of us, like the rest of the cosmos, are composed of pieces. We consist of atoms, molecules, molecular complexes, and cells. And trillions upon trillions upon trillions of different mechanical and chemical interactions are possible among these parts.

Take the human hand, for example. Yours, busy holding this book in front of you, is poised in a state of dynamic tension. Substantial bones, tendons, muscles, nerve fibers, and skin are all acting in concert. Together they sense and coordinate so that you can gaze steadily at these letters.

Many such hands of different colors, textures, and sizes have helped us imprint ourselves on the surrounding world.

We've taken our mental conceptions and carved them into shapes and figures from solid rock and iron. We've converted our thoughts into actual physical things that have in turn in-

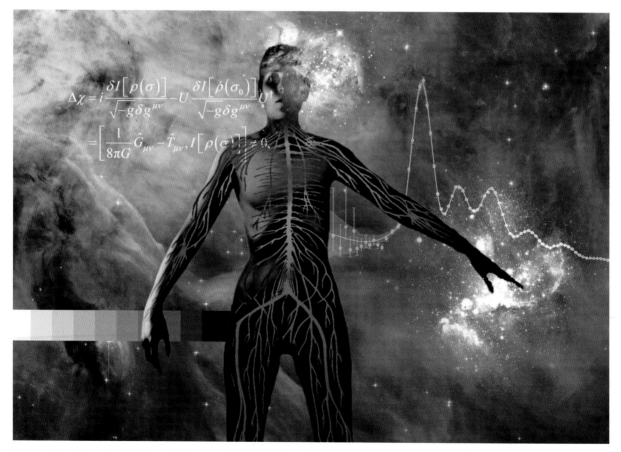

Human hands and cells have let us engage with the universe.

10^{-3}

Granularity of Life

The human hand is a sophisticated and complex assembly of diverse cells, tissues, structures, and chemicals. Together these interdependent components allow our species to express itself and impress itself on the surrounding universe. A typical hand contains 29 major joints, 123 ligaments, 34 muscles, 48 nerves, and 30 arteries.

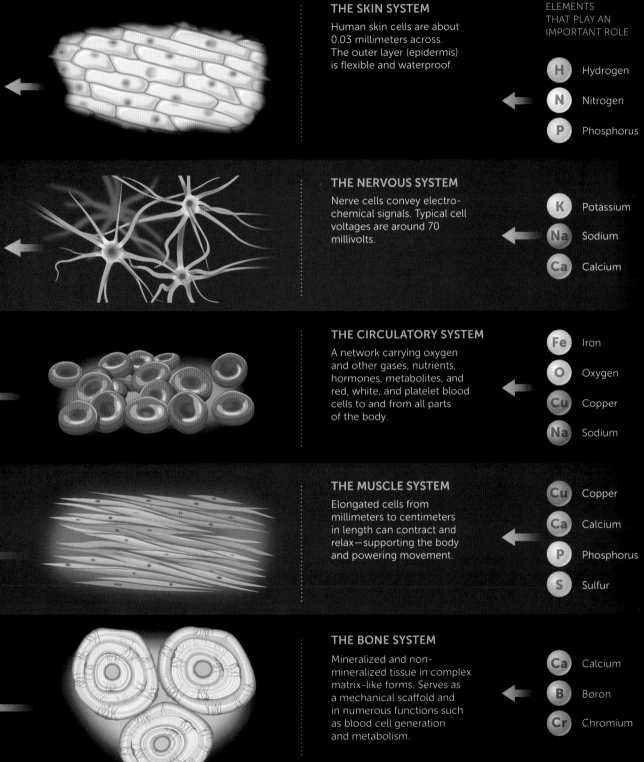

THE SKIN SYSTEM

Human skin cells are about 0.03 millimeters across. The outer layer (epidermis) is flexible and waterproof.

ELEMENTS THAT PLAY AN IMPORTANT ROLE

H Hydrogen

N Nitrogen

P Phosphorus

THE NERVOUS SYSTEM

Nerve cells convey electro-chemical signals. Typical cell voltages are around 70 millivolts.

K Potassium

Na Sodium

Ca Calcium

THE CIRCULATORY SYSTEM

A network carrying oxygen and other gases, nutrients, hormones, metabolites, and red, white, and platelet blood cells to and from all parts of the body.

Fe Iron

O Oxygen

Cu Copper

Na Sodium

THE MUSCLE SYSTEM

Elongated cells from millimeters to centimeters in length can contract and relax—supporting the body and powering movement.

Cu Copper

Ca Calcium

P Phosphorus

S Sulfur

THE BONE SYSTEM

Mineralized and non-mineralized tissue in complex matrix-like forms. Serves as a mechanical scaffold and in numerous functions such as blood cell generation and metabolism.

Ca Calcium

B Boron

Cr Chromium

spired ideas that have led to our hands making new things, and so on. Clever human fingers have let us fly in the sky, go to the Moon, and barrel into the outer reaches of our solar system. They've built machines to build other machines, from robots to self-assembling computers. They've also constructed microscopes out of carefully formed lenses and sensors, as well as enormous electromagnetic particle accelerators designed to dig deeper and peer at the subatomic realm.

Yet your hand is not really a single entity at all. This appendage consists of about 400 *billion* cells—highly specialized, membrane-wrapped capsules averaging about 0.03 millimeters across. It's the concerted action of these tiny machines that lets you hold this book, just as other tiny machines are letting me type these words. And on a grander timescale, it's the group action of these machines that helps drive human evolution.

The same is true for the rest of our bodies. It is also true of all large life-forms on Earth. By zooming into the Rift Valley in Africa, to an elephant, to a bird, to an insect, and on into that insect's cellular structure, we can glimpse this granularity of life. It is remarkable what all those teeny tiny pieces do when they get together.

THE SIMPLICITY OF COMPLEXITY

But these cellular machines also come and go. Human red blood cells live for some four months; skin cells live for a couple of weeks. Other cells, such as those in a human colon, live for just a few days. Even when you die, many of your cells will live on for hours or days. The cells of a multicellular life-form are as much about themselves as they are about their host.

Cooperative communities of life have existed on Earth for a long while—probably for at least as long as three billion years if you count the first simple colonies of cyanobacteria, with variants of multicellularity being "reinvented" many times as a biological strategy. Multicellular organisms with differentiated cell types—plants, animals, and fungi—began to appear between half a billion and a billion years ago. The cooperation and cohabitation of cells offers a variety of evolutionary advantages in the right environmental conditions. Multicellularity has resulted in organisms today existing with a range of masses spanning an astonishing twenty-two orders of magnitude (twenty-seven, if you count viruses as organisms). Life on Earth extends from the smallest microbes (10^{-16} kilograms) to the largest plants and mammals (10^6 kilograms).

A louse's compound eye, and a grain of pollen on a whisker

10^{-4}

Cooperation yields much more than evolutionary one-upmanship on other organisms. Together cellular units can build something far greater than the sum of their parts. Trillions of them can organize into fungi, plants, bugs, birds, and mammals. They can build humans like Albert Einstein, Ada Lovelace (the first computer programmer, and daughter of Lord Byron), Isaac Newton, and Marie Curie, or like Wolfgang Amadeus Mozart, Johann Sebastian Bach, Pablo Picasso, Frida Kahlo, Mary Shelley, and Leonardo DaVinci.

They can also create surprising simplicity from complexity. In animals, for example, there is an observed mathematical relationship between basal metabolic rate (how fast animals burn chemical energy while resting) and body mass. This relationship actually holds from bacteria to tiny shrews, and all the way up to enormous blue whales: the metabolic rate increases with body mass to the power of three-quarters. That's a law that runs across the whole 10^{22} span of masses for living things.

Life's Orders of Magnitude

Earth's organisms span at least 10 orders of magnitude in size—from single cells to multicellular giants. They also span 22 orders of magnitude in mass (27 if we count viruses).

MASS MAGNITUDE

10^{-21} kg	10^{-18} kg	10^{-17} kg	10^{-16} kg	10^{-15} kg
Small virus	HIV	Giant virus	Prochlorococcus	E. coli

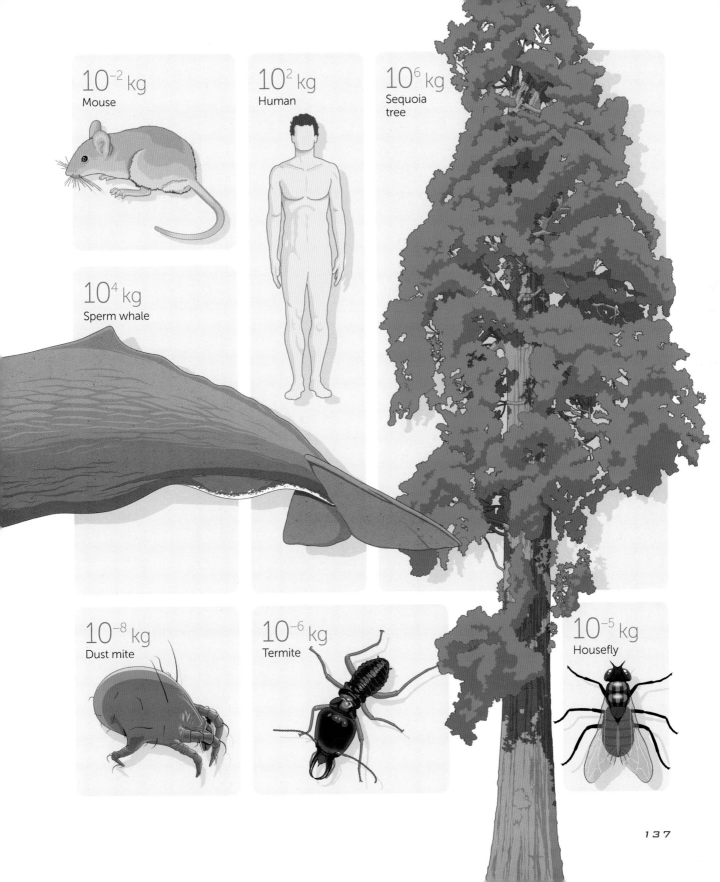

10^{-2} kg
Mouse

10^2 kg
Human

10^6 kg
Sequoia tree

10^4 kg
Sperm whale

10^{-8} kg
Dust mite

10^{-6} kg
Termite

10^{-5} kg
Housefly

A mouse and a whale contemplate each other
across two orders of magnitude in scale.

Representation of a neuron cell body

Somehow, a regular and straightforward law emerges across all those assembled biological cells in radically different species and sizes. Other characteristics in biology also show surprising regularity. For example, the ways in which life spans, growth rates, and physical sizes scale with one another also exhibit simple mathematical relationships.

How can this be? It's a fair bet that these are all manifestations of optimization, driven by natural selection favoring organisms that, putting it crudely, do the best with what they've got. But it works because a complex system of many parts can operate and cooperate across many scales.

The same is true in the collective behavior of multicellular organisms. They often form groups, herds, flocks, schools, or swarms. These gatherings behave like new types of entities with their own emergent laws. Their member creatures may each follow simple rules, but en masse they generate unexpected forms of cooperation as they move through the world.

10^{-5}

Those cooperative patterns are recognizable across radically different species. For example, starlings in their great "murmurations" swoop and stream like a school of herring in the ocean. For both species, the advantage to this group behavior likely arises from creating a sensory overload for potential predators. But it also creates hazards, such as attracting the attention of those very same predators.

Humans are not excluded from this club. We are social animals, bound by language and by the almost unspoken advantages of working together. Research has shown that our cities also follow a number of quite simple mathematical codes. Lengths of roads and electric power lines, and number of gas stations, scale in specific ways with the total population of a city. Wages, violent crime, and disease scale with population too, although differently.

Natural collectives can also solve computational problems with elegant simplicity. For example, pheromone paths laid down by individual ants en route to food sources from their nest are reinforced faster when the round-trip is shorter. So over time more and more ants will follow that shorter path. Consequently, the colony "discovers" the quickest way to feed itself.

A calculus of cost versus benefit for group behavior works across all species. There are good reasons why some creatures are loners and some are best off in a swarm of millions. Our own societies, cultures, financial systems, and individual behaviors are certainly governed by these rules.

All these properties—from the assembly of cells into larger organisms to the emergence of new behaviors and capabilities—are rooted in complexity. But complexity itself has roots in a more fundamental property of the cosmos, something we call entropy—a measure of disorder. As our journey takes us to even smaller scales, we will discover that entropy and uncertainty are more and more important. They are part of the glue that makes you, your hands, and your cells possible.

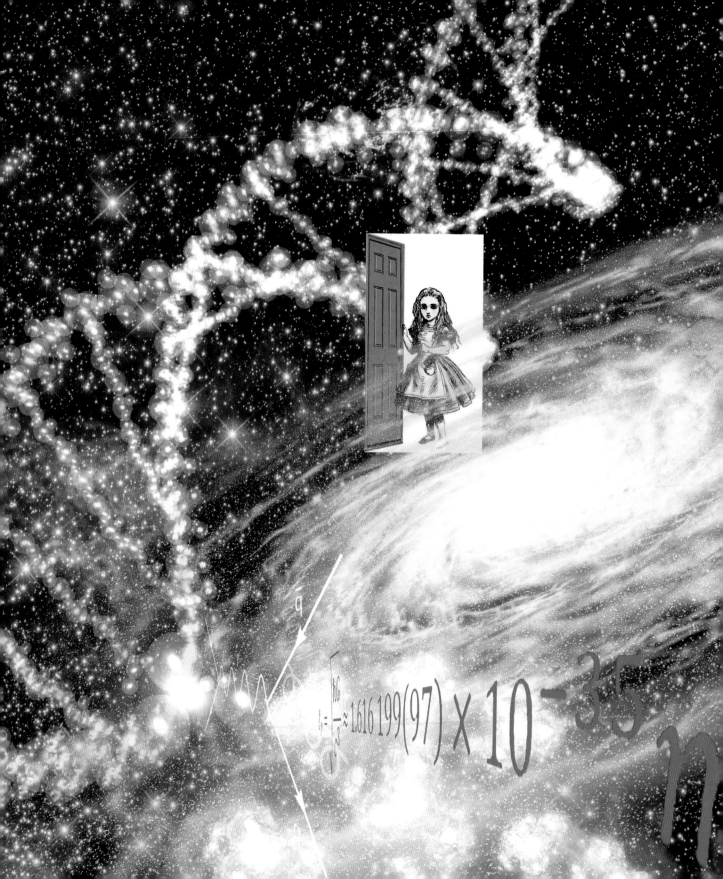

$$\ell_p = \sqrt{\frac{\hbar G}{c^3}} \approx 1.616\ 199(97) \times 10^{-35}\ m$$

In the eye of the storm: A meteorological plane ventures across the eyewall of a hurricane.

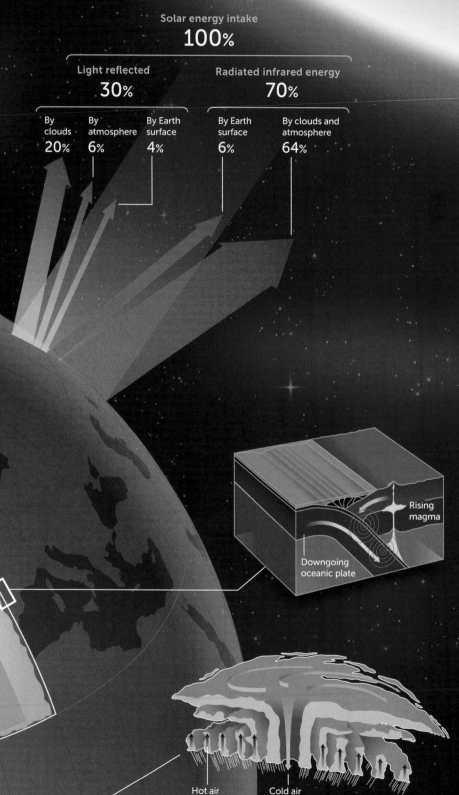

Solar energy intake
100%

Light reflected **30%**			Radiated infrared energy **70%**	
By clouds **20%**	By atmosphere **6%**	By Earth surface **4%**	By Earth surface **6%**	By clouds and atmosphere **64%**

THE SUN'S POWER

Solar radiation ranges from gamma rays to visible light to radio waves. Total solar irradiance, a measure of total power added over all wavelengths, peaks in visible light. Altogether, Earth receives only 1/10,000,000 of the Sun's total power output.

VOLCANOES AND EARTHQUAKES

Earth is geophysically active. Altogether, about 47 terawatts of power at the planetary surface come from geothermal and geochemical processes.

Rising magma

Downgoing oceanic plate

HURRICANES AND TYPHOONS

Warm, evaporating ocean water heats the atmosphere when it condenses—driving large low-pressure systems with circulating winds. Energy release rates can hit a petawatt.

Hot air Cold air

8

THE UNDERGROWTH

10^{-6}, 10^{-7}, 10^{-8}, 10^{-9}, 10^{-10} meters

From I micrometer (micron) to I Angstrom (or 0.1 nanometer)

From the size of a bacterium (prokaryote) to the approximate diameter of a hydrogen atom

Early on in this grand journey through the scales of the universe, it took just five steps in order of magnitude to go from the scale of the observable universe to our local galactic collective. That was a major transition, from a size where the cosmos is, well, *the* cosmos—an encapsulation of all space, time, and physics as we know it—to the domain of a few scrappy galaxies, each with an individual tale to tell.

Brace yourself, because you're about to go on a more mind-bending trip. Here, in another five orders of magnitude (from one micrometer to a tenth of a nanometer), is the shockingly brief passage from a reality we might recognize to the very strange places that exist not far beneath the range of our day-to-day senses.

Picture yourself taking a walk through a series of connecting rooms, right out of *Alice's Adventures in Wonderland*. Each room is separated from the next by a narrow door that you open and pass through. Stepping through each door, your view of the world shrinks in scale by another ten times.

Open the first door. Here, filling the room ahead, coated in a sticky film of gunk, is a living bacterium. This single-cell entity is a concoction of humming biological machinery contained inside a translucent membrane, forming a structure much like a capsule. At one end of the capsule is a spinning and whipping tail, or flagellum. On the surface are countless tiny hair-like

Bacterial biomass could be **350 to 550 BILLION*** tons of carbon. That equals **1/3 TO 1/2** of the total global biomass

Prochlorococcus is possibly the most plentiful species on Earth: a single milliliter of surface seawater may contain **100,000** cells or more

Worldwide, there are estimated to be **several octillion (~10^{27}) individuals**

Prokaryotes may have a global biomass of **550 BILLION TONS** of the Earth's dry biomass

COPEPODS may form the largest biomass of any animal species group

THERE ARE TYPICALLY 1,000,000,000 TO 10,000,000,000 BACTERIAL CELLS IN A GRAM OF SOIL

Antarctic krill form one of the largest biomasses of any individual animal species **500 MILLION TONS**

The length of all DNA in your body's cells **74 billion kilometers** (OR **193,000 TIMES** THE DISTANCE FROM THE EARTH TO THE MOON)

The length of all human DNA on planet Earth is **58 million light-years**

* Some studies indicate this biomass may be a smaller 50 billion to 250 billion tons of carbon.

extensions called pili. Inside the capsule is a mess of genetic material: a lengthy DNA strand, small loops of double-strand DNA known as plasmids, and a crowd of smaller compounds and molecular structures.

This bacterium is a fully fledged biological entity. It's a busy chemical factory, with compounds endlessly filtering in and out of its membrane covering. As alien as it appears, the bac-

A bacterium, with a flagellum (tail) and a peppering of viral invaders

10^{-6}

terium's actions also feel purposeful. It senses the world around it through chemical messengers and electrochemical variations, and responds to those senses.

Squeeze past this organism and move along to the door leading to the next shrinking room. Take a deep breath and pull it open. An even more alien and unsettling form fills up the space. Here is a single virus: a collection of molecular structures, wrapped up in a knobbly and pod-like casing. It's a nub of tightly packed protein molecules arranged about a small loop of genetic material—the virus's code. Is it alive? Perhaps not in the sense that you are familiar with, but it is certainly not inert: as you watch, it drills its way into the genetic substructure of some other helpless cell.

Something odd is also happening to your vision in this room. The virus is hard to see distinctly. The light that you usually rely on to perceive the world is not interacting the way you expect with this tiny object. In fact, the wavelengths of visible light are larger peak-to-peak than the virus. These waves no longer reflect from or pass through this object in a consistent way. The virus doesn't so much appear directly. Instead, it merely muddles the light. Squinting, you press on to the next scene.

You have to fumble and probe your way forward as you swing the third door open. Visible light is next to useless here. Instead, you feel the electrostatics of your own shrunken body interact with the thing lurking in this next room. It's like wearing a blindfold, clumsily reaching for the way ahead, and discovering your hands on an undulating, bumpy, stringy *something*.

This is the room of giant molecules. The scary object is a ribosomal assemblage, a centrally important structure for the phenomenon of life—a station for synthesizing proteins. This intricate form moves and shape-shifts as you reach for it. The ribosome attaches to other molecular structures and works its way through a sequence of actions, as if part of an assembly line. Molecular arms and pivots gather and manipulate simpler molecules, such as amino acids, to join them into larger structures.

The process is graceful and precise, even as it is full of agitated movement and vibration. The ribosome takes mere minutes to accumulate and assemble vital pieces of cellular life's components. You can feel new threads of proteins ticker-tape out from its maw, tumbling and folding as they do.

While it works away, you squeeze through, dodging past its electrically sticky protuberances, and continue on to the next drastically shrinking room. Through that fourth door, a busy molecular tumble is replaced by the quasi-regularity and symmetry of a sequence of thin, twisted DNA that has drifted past the ribosome.

A myovirus bacteriophage prepares to inject its genome into the cytoplasm of a bacterium.

10^{-7}

At this scale what you actually sense is a space of possibilities, of ethereal electrostatic pushes and pulls. The closest comparison we can make to this experience is a blindfolded tasting of unknown foods and flavors. There is a menu of such sensations here, unique flourishes lined up end to end.

Here's an entity we call a carbon atom. Here are ones called oxygen, nitrogen, hydrogen. They're clumped together as other recognizable things, relatively simple molecules called nucleotides: adenine, thymine, guanine, cytosine, arrayed along a pair of sugar-phosphate rails that curve off into the distance in either direction.

But what any of these *look* like is no longer entirely meaningful. What *is* meaningful is the "state" of these entities, their electromagnetic energies, their vibrations and rotations, their still-intangible patterns of presence. Walking among them you are buffeted by a multitude of calls and entreaties in the form of attractions and repulsions, yet this seemingly disordered cacophony is shot through with regularity and information.

ACROSS THE THRESHOLD TO THE STRANGE

And now comes the fifth door, the next level down. Except this time, as you pass across the threshold, something very odd happens. You sense a change in yourself, a change that was hov-

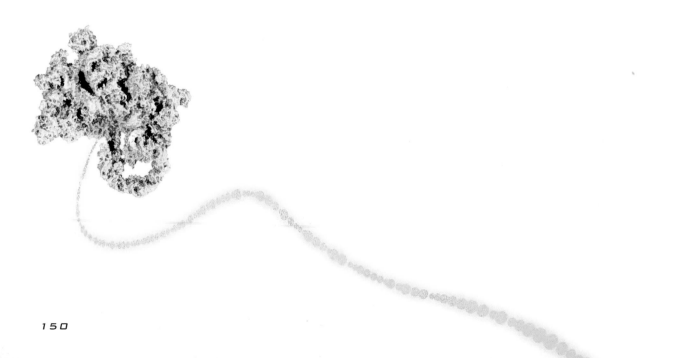

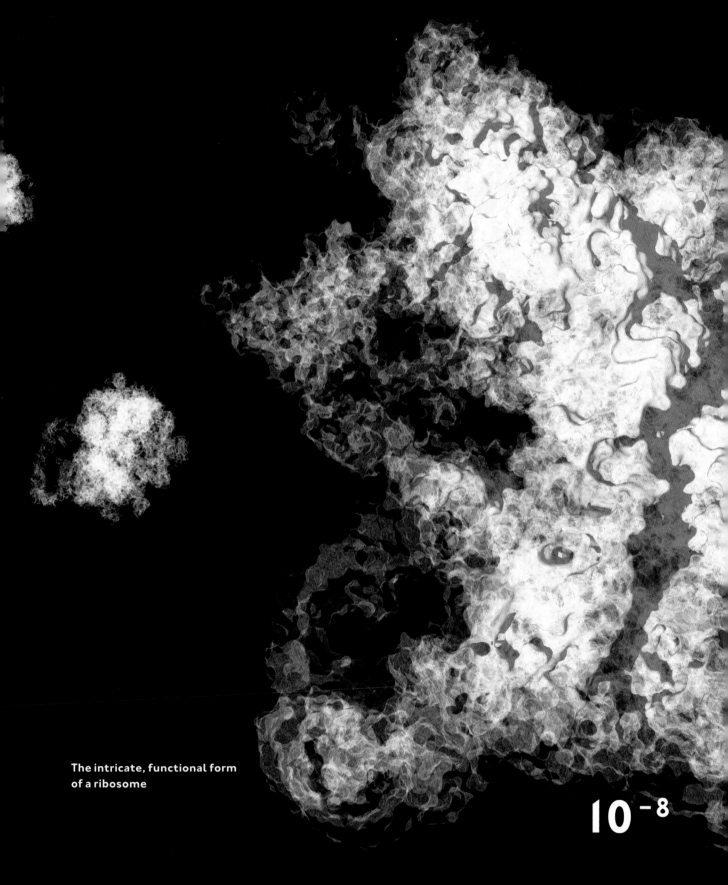

The intricate, functional form
of a ribosome

10^{-8}

ering at the periphery of your awareness at the last doorway and is now almost all that you experience. It is as if you've suddenly ascended to a great altitude, exhaling and expanding.

You are no longer quite the integrated thing that you were. You are spread out, simultaneously *here*, and *there*, and over *there*. And the structure in front of you, which happens to be a carbon atom, is similarly *odd*. You don't feel this atom in any distinct way. Instead you mingle, sharing space and time. You mostly exist right before the atom, but you exist to the sides too. The atom reacts to your intrusion. Its electrostatic field is a dancing cloud of negative charge, yet the cloud has structure to it, areas of more or less charge. And lurking somewhere deep inside is a positive electrostatic charge that keeps a critical grip on everything.

Welcome to the quantum world. In truth, you haven't been altered by passing through the doorway—you've simply been exposed to an underlying aspect of your nature that was there all along. Specifically, you've just been *diffracted* because of your shrunken state.

Normally, you exist at a scale where your body consists of a thousand trillion trillion atoms in an assembly ten billion times larger than a single atom. And you move around quickly, at meters per second. Any diffraction in passing from one scale to the next smaller power of ten has been beyond your perception, or that of any current measurement device. But now, at this tiny scale of a tenth of a billionth of a meter, you can't waltz through a doorway between magnitudes and hope to be just fine. The particle-wave duality of matter—the deeper truth of reality—is in full force. On these scales the universe is a place of probabilities, of statistics, a dance of a multitude of branching pathways and curious relationships. That weirdness is at the heart of reality—it is what lets us exist.

THE CARBON COSMOS

Life, as we currently know it, is built around the element carbon. Why is this?

Carbon atoms just happen to be great at building all sorts of molecules. Carbon atoms are like your favorite pieces in a Lego set—the pieces that always let you complete your most ambitious projects.

Carbon atoms harbor six electrons. When these electrons are all nicely settled, four of them (called valence electrons) can easily be attracted to the nuclei of other atoms and share space with

A strand of deoxyribonucleic acid (DNA)

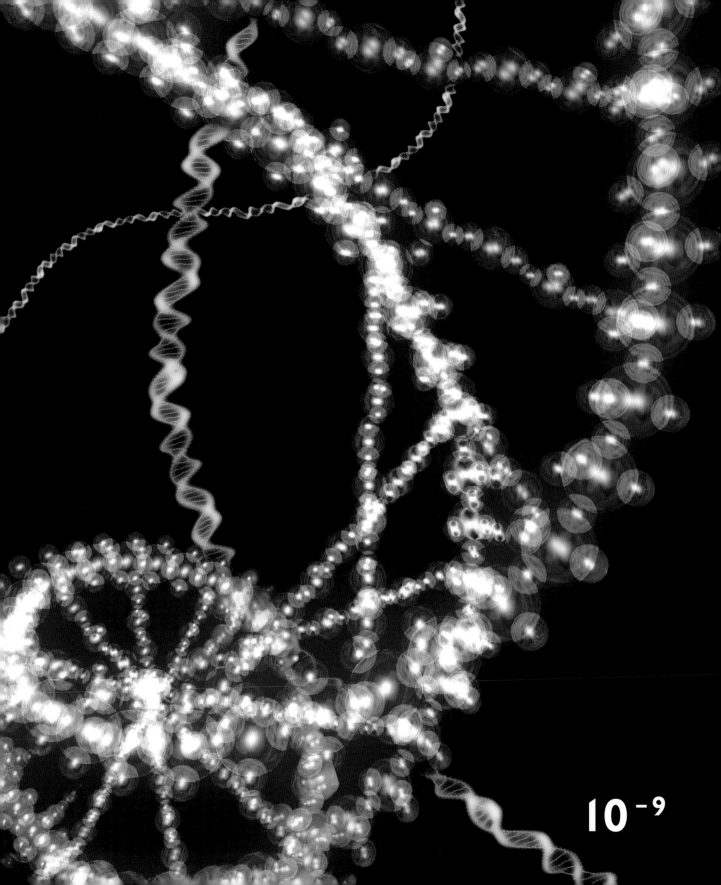

10^{-9}

those atoms' electrons. In quantum-speak, these valence electrons occupy zones of spatial probability around a carbon atom that let the atom associate with other atoms—or, in other words, form chemical bonds.

For example, one of the carbon atom's valence electrons can form a covalent bond with the valence electron of another atom (like hydrogen), where the two electrons are effectively shared between the atoms in a state of "quantum superposition." (This is a piece of the quantum weirdness that we'll encounter more and more as we descend in scale.) The new carbon-hydrogen molecule will have an overall lower energy state than the two separate atoms. Why does this matter? Because that lower energy increases the probability of the bond forming.

Of course there are plenty of other elements with four valence electrons. For example, the next heaviest elements with this electron complement are silicon and germanium. The difference is that carbon atoms are lighter and smaller, and the energy changes that go into making or breaking carbon bonds are more modest. The upshot is that carbon-based molecules are kinetically nimble, and simultaneously able to form, preserve, and break bonds at temperatures where other, inorganic chemistry happens. This is especially true in the presence of liquid water, which serves as an incredible solvent and enabler of chemical mobility. And to top it off, carbon atoms bond readily to other carbon atoms to make long polymers, or chains and branches, and other complex molecular structures.

Where carbon comes from in the universe is also a deep function of quantum physics. Like all the heavier elements, it is produced via nucleosynthesis (from nuclear fusion) in stars. But the high abundance of carbon (it comes in fourth in the count of atoms in today's universe, after hydrogen, helium, and oxygen) relies on several key properties of the cosmos.

Most carbon forms through the triple-alpha process: the fusion of two helium nuclei into a beryllium-8 nucleus, followed by the fusion of the beryllium nucleus and another helium nucleus into carbon. This would be a horribly inefficient way to make carbon, except for some subtle coincidences. These coincidences are pretty technical, and may only be truly relished by nuclear physicists, but they're worth knowing about because they can help you grasp the connections between fundamental physics and us.

The first coincidence is that in a star's interior, the combined energy of a beryllium-8 nucleus and a helium nucleus can closely match that of an energized carbon-12 atomic nucleus. This "resonance" in energies is key; it greatly enhances the rate of the next fusion step—making

The probability-density cloud of electrons bonding a carbon atom to four hydrogen atoms

10^{-10}

carbon-12. The second coincidence is that the nuclei of beryllium-8 just happen to be stable for long enough for them to have a good chance of catching one of those helium nuclei as they buzz around. And finally, the new carbon-12 nucleus is not efficient about immediately fusing with any spare helium nuclei to make a heavier oxygen nucleus—the carbon doesn't get gobbled up into oxygen, and lives to build your DNA a few billion years later.

Another way of looking at this is to say that our existence, and the existence of life as we know it, is acutely dependent on these esoteric bits of physics. Some thinkers take that as a sign of deep connections between life and cosmology—an "anthropic principle": the universe had to be "just so" for us to be here to observe it. For others, it's just how things happened to turn out—especially if the cosmos is just one part of a multiverse. You may have your own thoughts on whether or not the universe was compelled to produce life. In either case, it's good fodder for late-night arguments.

These nuclear tales and puzzles, and the shrinking rooms of this stage of our journey, are just a taste of what's coming next. Now that we've dipped a toe into the quantum universe, let's dive deeper down into the roots of existence itself.

The Life of a Carbon Atom

No other element plays such a critical role in our lives. Our complex biochemistry relies entirely on carbon's ability to form robust yet flexible molecular bonds. Each one of the 10^{26} carbon atoms in your body has experienced a deep history of chance, contingency, and convergence.

1. Inception
10 billion years (10 Gyr) ago, during peak star formation in the cosmos, triple-alpha helium fusion process inside a massive 25-solar-mass star produces a carbon-12 nucleus from primordial helium nuclei.

2. A million years later, the star goes supernova, dispersing the carbon nucleus to space, where it acquires electrons to form an atom.

3. Carbon atom drifts in interstellar space for 2 billion years.

4. Atom bonds with an oxygen atom to make carbon monoxide (CO) that drifts in interstellar space for another 2 billion years.

5. CO gets caught up in the collapse of a molecular cloud/nebula in the galaxy.

6. CO gets mixed into proto-planetary disk system.

7. After a few million years, CO reacts on an icy dust grain, making methyl alcohol (CH_4O) that gets embedded in a rocky body.

13. Eventually, after 300 million years (100 million years ago), CO_2 is consumed by new surface plant life.

12. About 3.5 billion years later (about 400 million years ago), carbon is released by volcano as CO_2 again into atmosphere.

11. 100 million years later, limestone is subducted into Earth's upper mantle.

10. CO_2 is consumed by a bacterium; bacterium causes carbon to be deposited in limestone on ocean floor.

9. 100 million years later, carbon is released into Earth's atmosphere in a carbon dioxide molecule (CO_2).

8. Rocky body falls to surface of young Earth just after lunar formation (4.5 Gyr ago); carbon becomes mixed into magma ocean.

14. Plant gets eaten by dinosaur; carbon is incorporated into an amino acid molecule.

15. Dinosaur dies, decomposes; carbon is eaten by insect and incorporated into insect exoskeleton.

16. Insect body is incorporated into silt deposit of inland sea.

17. Sea dries, silt strata remain; over millions of years, erosion carries carbon in rock particle that is washed to a surface soil deposit.

18. Human grows potato plant in that soil. Carbon sticks to potato as organic matter.

19. You consume potato; carbon atom is incorporated into your DNA and is within a cell in your retina as you read this page.

Inside the atom

10^{-11}

9

THE EMPTINESS OF MATTER

10^{-11}, 10^{-12}, 10^{-13}, 10^{-14}, 10^{-15} meters

From 10 picometers to 1 femtometer

From X-ray wavelengths to the approximate size of a carbon nucleus

Make a fist. Now imagine that your fist represents the size of an atomic nucleus. If it did, the entire atom would extend to about five kilometers in all directions. Atoms are 99.9999999999999 percent empty space (a typical atomic nucleus takes up one-trillionth of its atom's volume but holds 99.9 percent of the mass).

Consequently, you could crush all seven-plus billion humans into a single mass the size of a sugar cube simply by squeezing out all that empty atomic space. In exotic locales like neutron stars, that is precisely what gravity does, creating an object made of a special state of nuclear matter (degenerate matter) that is only ten to twenty kilometers across, yet contains the mass of a star.

All that emptiness also means that the next leg of your journey, from a scale of 10^{-11} meters (10 picometers) down to 10^{-15} meters (a femtometer), is phenomenally dull. It's actually worse than your much earlier traversal of the scales of intergalactic and interstellar space. At least there you'd occasionally have a molecule or an interstellar dust grain for company. Within the atom, even the flitting electrons are scant compensation. Although their physical size is not an easily definable thing (or even very meaningful), some experiments suggest that an electron is at least ten million times smaller than an atomic nucleus.

What this trip through the emptiness of an atom *does* give you is more time to think about

If your fist were a nucleus, this would be the extent of the atom.

the fundamental nature of the space enveloping you, and how it's connected to the strange phenomena you experienced at your smallest in the last chapter.

The quantum nature of fundamental reality is one of the most conceptually challenging pieces of our current quest to understand the universe. Yet, as mind-bending as quantum physics is, this is evidently the way the universe works.

Where we have successfully melded mathematical descriptions of quantum physics to nature (such as in atomic physics), we've produced some of the most precise and accurate predictive tools yet known to humans. In the quantum domain we've also conducted some of the most precise *experimental* measurements of any fundamental cosmic properties. For example, we've measured esoteric yet important quantities such as the so-called anomalous magnetic moment of the electron with an astonishing precision of more than eleven decimal places. Our theory of

Still inside the atom; a speck appears in the distance

10^{-12}

quantum electrodynamics (QED, which contains relativistic physics) had accurately predicted this quantity *to the same level of precision.*

Our mathematical physics of the very small works exceedingly well, and it's a framework containing many versatile tools. These range from the constructions of wave functions and Dirac matrices to the elegant intuition of Feynman diagrams for describing particle interactions. We've also come up with powerful, highly mathematical devices with imposing names like "symmetry groups," "Hilbert spaces," "operators," and "eigenvalues."

But at the core of it all is a type of counterintuitive physics that still baffles us. The Heisenberg uncertainty principle tells us that properties of objects and systems can be inextricably connected by being complementary. For example, the *position* and *momentum* of a particle can never both take on exact values: the better one of those is defined, the less defined the other. That uncertainty is not simply an effect of our *observation* of the particle; it is intrinsic.

Tiny objects exhibit properties that can be attributed to either discrete particles or to wave-like entities—characteristics that in our classical, macroscopic world are typically incompatible with each other.

Scientists are still trying to sort all of this out, and we have a few options to turn to for help making sense of our quantum reality.

THREE TAOS FOR QUANTUM PHYSICS

For example, the so-called Copenhagen interpretation of quantum mechanics says that the only reality is one of probabilities and statistics. It's dice rolling all the way down. Particles are literally neither here nor there *until something interacts with them.* Their whereabouts are given by a cloud of probabilities, described by a wave function, whose precise behavior is captured by a mathematical device called the Schrödinger Equation. Observe (interact with) the particle, and the wave function "collapses" to define the particle's location and properties.

The Copenhagen interpretation says that before the wave function collapses, the particle literally does exist anywhere and everywhere that the equation says it might. If we don't like it, that's tough—nature doesn't care whether or not we're happy.

While that's the most popular view of the underlying nature of quantum mechanics, it's not

10^{-13}

Three Different Interpretations of Quantum Mechanics

Although quantum mechanics works extremely well for describing systems of atoms, photons, and subatomic particles, physicists still debate exactly what is going on at a deep level.

THE DOUBLE-SLIT EXPERIMENT

The weirdness of quantum mechanics is illustrated by a deceptively simple laboratory test in which electrons are fired at a pair of narrow slits, with a detection screen behind them.

NOT OBSERVED

Slits Screen

1 A single electron is fired, and detected on the screen. No observations are made in between.

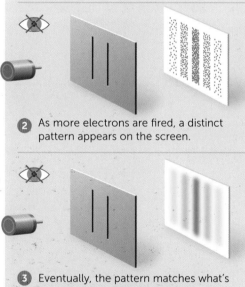

2 As more electrons are fired, a distinct pattern appears on the screen.

3 Eventually, the pattern matches what's expected from interference of a wave passing through slits.

But if each electron is detected (observed) going through the slits, the interference pattern doesn't form. The observer is influencing the experiment.

OBSERVED

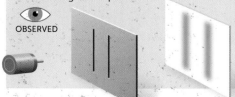

THE COPENHAGEN INTERPRETATION

 Niels Bohr

Slits Screen

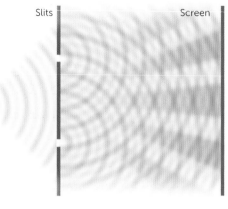

Electron has no definite position and passes through both slits with wavelike behavior before interfering with itself to form screen pattern. Observing "collapses" the wave, leaving just particle-like behavior.

THE DE BROGLIE–BOHM, OR PILOT-WAVE, INTERPRETATION

 Louis de Broglie & David Bohm

Electron has definite position, and passes through one or the other slit, but is guided by "pilot wave" that creates interference pattern determining where electron ends up. Observing collapses pilot wave.

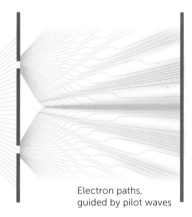

Electron paths, guided by pilot waves

THE MANY-WORLDS, OR EVERETT, INTERPRETATION

 Hugh Everett III

Electron follows all possible paths, each one in a different parallel universe

Electron buffeted by versions in parallel universes, also buffeting one another

Electron in our reality has duplicates in a huge number of other realities. Double-slit result might be explained by these realities impinging on one another at the electron's location.

the only one. For example, an alternative view was proposed back in the early and mid-twentieth century, which says that there really *are* particles that exist as discrete "classical" entities with definite locations, but that they exist hand in hand with something called a "pilot wave." The pilot wave determines the way the particles move and how, for example, they diffract and interfere (an otherwise wavelike property that you encountered briefly at the 10^{-10}-meter scale—the final shrinking doorway that diffracted your body). We need two equations to work with this interpretation of quantum reality: one is a wave function, and the other links the particle's behavior to the wave.

This so-called de Broglie–Bohm version of quantum mechanics makes many of the same predictions as the Copenhagen Interpretation, but it sticks to having particles be particles and waves be waves. This version also implies that the universe is deterministic. So if you knew all properties of matter in the universe at this instant, you should (in principle) be able to predict what will happen in the future.

But a thorny issue called non-locality comes into play. In essence, two particles that have once been associated with each other—for example, produced in the same subatomic process—will remain linked (entangled) when they head off into the cosmos. The subsequent state of one particle will appear to affect the state of the other—even if they are great distances apart. It's a property that can be verified in experiments using photons, atoms, or even tiny solid objects. It is also one of the weirdest aspects of the quantum domain.

The Copenhagen interpretation deals with this "spooky action at a distance" (Einstein's phrasing, to describe his skepticism about the whole nature of quantum physics) by essentially shrugging and saying, "That's just how it is." The de Broglie–Bohm interpretation tries to one-up this by stating that the wave function of a system has no spatial limits—it literally spans the universe—and

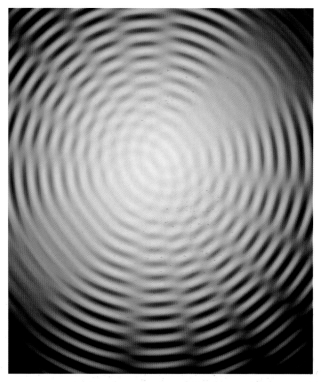

Wavelike interference patterns

Does each event split reality into an infinity of possible worlds?

the behavior of one particle is always bound to any other particles governed by the same wave function.

But there's yet another way of trying to understand quantum mechanics: the many-worlds, or Everett, interpretation. In basic terms the many-worlds picture says that wave functions describing the probabilities of certain things happening neither "collapse" nor "guide" particles. Instead, all eventualities that can happen *do* happen—they just don't happen in a single reality.

It is a hugely provocative meta-theory: for every possible outcome of an electron's bumping, every photon's refraction or diffraction, every radioactive decay, every subatomic event in the universe, there is a separate reality—a parallel existence—in which that specific outcome occurs. In other words, the instantaneous reality we experience is merely one pathway through an infinite tree of alternate pathways all happening at the same instant.

With ideas like this, no one can accuse physics of being boring!

COLORS, FLAVORS, AND COMPOSITES

All these quantum cogitations help you pass the time during your descent into the emptiness of an atom. But as we approach a scale of 10^{-15} meters, it's time to take a closer look at some of the raw ingredients of the universe. We're about to come nose-to-nose with nuclear physics.

At the core of every atom is its nucleus. The simplest of all is a single proton, a positively charged particle with a mass about 1,836 times that of an electron. To add more protons together, nature also requires the addition of neutrons—electrically neutral particles barely 0.14 percent more massive than protons. Roughly speaking, stable nuclei tend to have very similar numbers of protons and neutrons. But overall, the ratio of neutrons to protons gradually grows with the size of the nucleus. For example, the most common stable iron nucleus has 30 neutrons and 26 protons.

Atomic nuclei are tricky beasts. They're complicated in the sense that the protons and neutrons "feel" the presence of all the other protons and neutrons through a nuclear force (the "residual strong force"). And the complete nucleus can exhibit a range of behaviors. These include "excited" energy states, and even situations where pairs of neutrons lurk outside the primary nucleus—so-called halo nuclei. Over the years, physicists' models for nuclei have included char-

…terizing them as liquid drops, or as full quantum objects with energy shells much like those of an atom's electrons.

The variable number of neutrons that can bind into nuclei with a given number of protons results in variants of elements called isotopes, a remarkable array of species that are often unstable (radioactive). The elements xenon and cesium hold the record for the most isotopes. Each totes up a staggering 36 varieties. Xenon has 9 stable isotopes and 27 radioactive ones. Cesium has just 1 stable variety and 35 unstable.

The atoms of different isotopes of the same element have similar chemistry, because the way they share and exchange electrons doesn't change much. But a combination of different isotopic masses and subtle shifts in electron energy levels does result in a number of detectable variations in behavior. Biology, for example, generally prefers lighter isotopes, for the simple reason that it takes less energy to do stuff with lighter atoms. That preference helps us detect the presence and decode the actions of living systems by looking at what isotopes exist in environmental samples. Temperature also differently influences the chemical reaction rates of different isotopes. This changes the ratio of isotopes in chemical compounds, and leaves telltale signatures that can last for hundreds of thousands, even millions or billions of years.

Earth's nuclear garden has its origins in our earlier travels through the realm of galaxies. Because our solar system is an interstellar condensation, all the atomic nuclei of the Earth have a deep history locked inside their 10^{-15}-meter span. In nature, nuclear fusion in stars builds heavy elements up to iron (with its stable total of 56 protons and neutrons). Beyond iron, fusion reactions are endothermic, meaning that they no longer release more energy than is required to start them. It takes violent supernovas, or the slow cooking of old and very massive stars, to form heavier nuclei. In these very high-energy environments, extra neutrons and protons can, in effect, be forced together even if the process absorbs rather than generates energy. These are places where elements like cobalt, nickel, uranium, and even plutonium are forged.

We have also devised ways to form even larger, more massive nuclei than nature typically makes. Super-large nuclei are peculiar: an island of relative stability appears at very high proton and neutron counts, related to favored energy levels within the nuclei themselves. The record holder for now is oganesson (formerly called ununoctium, from the Latin for "one-one-eight") with a colossal 118 protons (and 176 neutrons)—but it has a half-life of a mere 890 microseconds.

But where does all this rich complexity really come from? Critically, neither protons no…

An atomic nucleus of carbon

10⁻¹⁴

An atomic nucleus of carbon

10^{-14}

ATOMS

The smallest components of an element that exhibit the element's chemical properties. An atom consists of a small, heavy nucleus bonded by the electromagnetic force to one or more electrons occupying a much larger volume.

Molecules are groupings of two or more atoms bonded together that are the basic units of a chemical substance. Atoms in a molecule may be of the same or different elements.

Subatomic particles include **composite** and **elementary** particles

COMPOSITE PARTICLES

Particles that are composed of two or more elementary particles. The protons and neutrons in the nucleus of an atom are composite particles, as they are composed of quarks.

ATOM

NUCLEUS

Protons and **neutrons** make up most of the mass of the visible matter in the universe.
Electrons (the other major component of the atom) are leptons.

MOLECULE

MATTER

Subatomic particles

The building blocks that litter the universe, from photons to Higgs bosons and beyond. Properties such as mass, electric charge, and quantum mechanical "spin" characterize a number of distinct families. Subatomic particles can be ephemeral, being created and destroyed in different conditions. Energy and mass are interchangeable.

ELEMENTARY PARTICLES (not made of other particles)

Quarks cannot be observed directly, and come in six "flavors." Only quarks experience all fundamental forces: electromagnetism, gravity, strong force, and weak force.

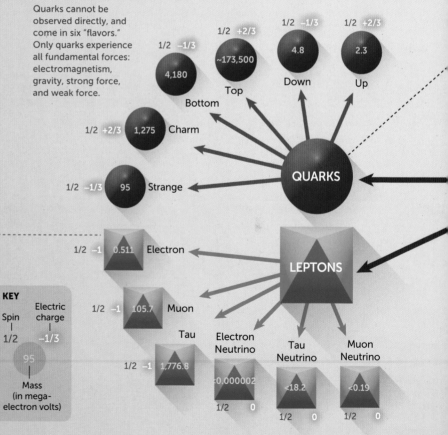

1/2 −1/3 4,180 Bottom

1/2 +2/3 ~173,500 Top

1/2 −1/3 4.8 Down

1/2 +2/3 2.3 Up

1/2 +2/3 1,275 Charm

1/2 −1/3 95 Strange

QUARKS

1/2 −1 0.511 Electron

LEPTONS

1/2 −1 105.7 Muon

1/2 −1 1,776.8 Tau

Electron Neutrino <0.000002 1/2 0

Tau Neutrino <18.2 1/2 0

Muon Neutrino <0.19 1/2 0

KEY

Spin | Electric charge

1/2 | −1/3

95

Mass (in mega-electron volts)

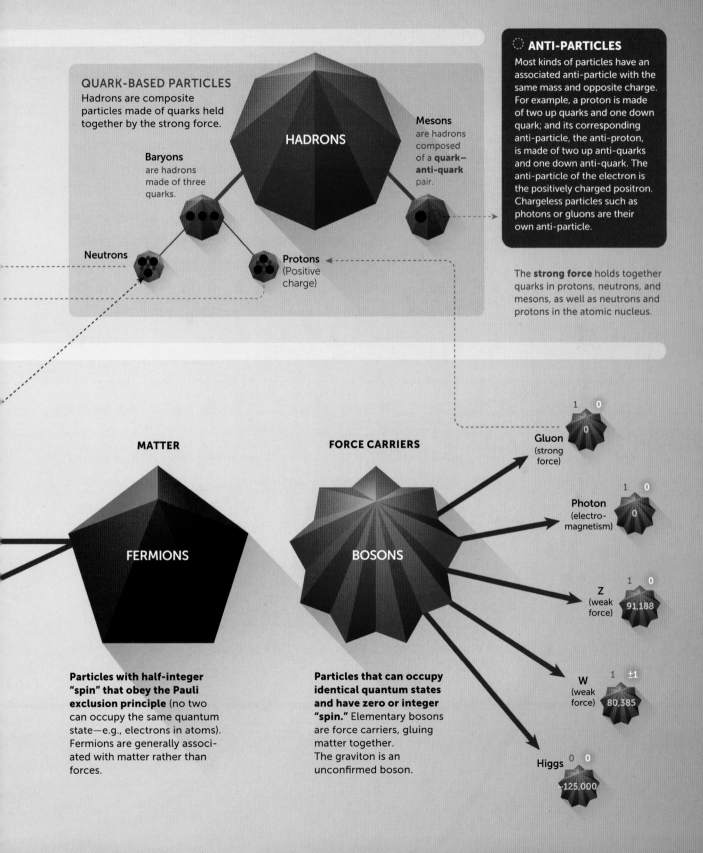

QUARK-BASED PARTICLES
Hadrons are composite particles made of quarks held together by the strong force.

HADRONS

Baryons are hadrons made of three quarks.

Mesons are hadrons composed of a **quark–anti-quark** pair.

Neutrons

Protons (Positive charge)

ANTI-PARTICLES
Most kinds of particles have an associated anti-particle with the same mass and opposite charge. For example, a proton is made of two up quarks and one down quark; and its corresponding anti-particle, the anti-proton, is made of two up anti-quarks and one down anti-quark. The anti-particle of the electron is the positively charged positron. Chargeless particles such as photons or gluons are their own anti-particle.

The **strong force** holds together quarks in protons, neutrons, and mesons, as well as neutrons and protons in the atomic nucleus.

MATTER

FORCE CARRIERS

FERMIONS

BOSONS

Gluon (strong force)
1 0
0

Photon (electro-magnetism)
1 0
0

Z (weak force)
1 0
91,188

W (weak force)
1 ±1
80,385

Higgs
0 0
~125,000

Particles with half-integer "spin" that obey the Pauli exclusion principle (no two can occupy the same quantum state—e.g., electrons in atoms). Fermions are generally associated with matter rather than forces.

Particles that can occupy identical quantum states and have zero or integer "spin." Elementary bosons are force carriers, gluing matter together. The graviton is an unconfirmed boson.

neutrons are truly fundamental particles. Rather, they are composites. A proton actually consists of three entities called "quarks" (two "up" quarks and one "down" quark), bound together by the strong nuclear force (or, color force), which is mediated by the exchange of massless "gluons" over very short ranges. Quarks carry a fractional electrical charge of one-third (one unit being the charge of an electron), and can engage in all the fundamental interactions—gravity, electromagnetism, and the strong and weak forces. A neutron is also composed of three quarks, one up and two down.

Take a deep breath—there's more. These are just the lowest-mass quarks. There are also more-massive ones (not found inside protons and neutrons) with different "flavors" called "strange," "charm," "top," and "bottom." Furthermore, 99 percent of the mass of protons and neutrons is due to the kinetic energy (energy of motion) of the quarks and the energy of the gluons (thanks to Einstein's relativity). The quarks themselves—if they could be isolated—would be low mass. And in a proton or neutron the three quarks are also awash in a cloud of virtual quark and *anti*-quark pairs known as "sea quarks."

If none of this fills you with any sense of security, welcome to the wild, wild world of the subatomic. After your fall through the emptiness of an atom, here is a new level of richness and activity.

Pause for a moment and consider this. Five billion years ago we were cosmic filth, scattered elements drifting through space, themselves composed of electrons, quarks, and gluons. Now we are a self-sustaining life-form that has evolved awareness of both itself and the surrounding universe. We've used the eighty-six billion neurons in our brains, and many generations of ourselves, to develop mathematical structures that enable us to grapple with an underlying reality that has almost *nothing* in common with our daily experiences.

This situation was beautifully summarized by the legendary Albert Einstein, who himself was stunned enough to exclaim that the most incomprehensible thing about the universe is that it is comprehensible. One could also say that the truly incomprehensible thing is that the universe is capable of comprehending *itself*.

Protons and neutrons are themselves composites.

10^{-15}

10^{-16}

IT'S FULL OF . . . FIELDS

10^{-16}, 10^{-17}, 10^{-18}, and . . . 10^{-35} meters

From a tenth of a femtometer to the Planck length

From approximate proton radius to nearly nothing

This is our final descent. Starting at 10^{-16} meters, or the approximate scale of a proton, we hop onto a trajectory that is going to take us all the way down to the very bottom of the rabbit hole.

Our ultimate destination is an astonishing *nineteen* orders of magnitude away. That's a journey equivalent to our earlier passage from the scale of the entire observable universe to the parochial familiarity of the Earth-Moon system. And it's all *inside* a single proton.

The innards of that proton are far more messy and inelegant than we might have expected. Although this composite object is experienced by the outside world as if it simply contains two up quarks and one down quark, that is only part of the story.

Look closer and we find that the structure of this composite particle is a stew of gluons and virtual quark and anti-quark pairs—popping in and out of existence within the allowances of the uncertainty principle. Energy and time are borrowed and balanced; stuff appears and disappears before the universal bookkeepers can get angry.

If, for an instant, you could set aside all the virtual quarks and anti-quarks that complement one another, the two up quarks and one down quark would be all that remain. These three are what the outside world senses—the asymmetry in the stew.

At these scales, and in such an alien environment, it makes sense to modify our earlier ideas about a reality composed of "particles" and "waves" (although the mathematics of waves is still a

LEFT: **The interior of a proton is a sea of virtual particles.**

OPPOSITE: **A virtual mush**

critical part of the language on these scales). Instead, we're better served by thinking about what we'll call "fields" and "quanta."

FROM STONE TOOLS TO FIELD THEORY

A field is a mathematical function—an algebraic contraption that generates a result that in some instances might depend on a physical position (an x, y, and z) and the time. That result might be the length of a piece of elastic, the pressure of air, or the height of the ocean surface at a specific location and moment. The concept of a field is abstract enough so that it might also apply to all sorts of quantities and phenomena, not necessarily material, from esoteric mathematical groups to the scope of a politician's ego.

10^{-17}

Critically, you can also attribute a field to many fundamental phenomena in physics. For example, electromagnetism can be encapsulated by the mathematics of a field. So too can gravity in Einstein's formulation of general relativity. In fact, a key property of a field in physics is that it doesn't necessarily have to concern itself with the medium in which it operates.

Fields can move or change in ways that allow them to carry *waves*. And those waves may only be able to exist in specific states. This behavior—if we skip a great deal of mathematical physics reasoning—brings us to the threshold of the notion of a "quantum."

Imagine a type of field within which energy can make waves propagate with a certain amplitude, frequency, and equilibrium (resting level). Ripples on a pond are one analogy. But it just so happens that there is a discreteness to the frequency of those waves. There is a smallest possible frequency (or longest wavelength), and it's not zero. This would be like seeing the pond ripples never occur farther apart than some maximum distance.

These are the properties of a relativistic quantum field. That smallest possible frequency actually corresponds to a quantum of the field. Like the farthest-spaced ripples on the pond, that quantum has a minimal energy, and that energy corresponds to the mass of what we've been calling a particle (thanks to Einstein's famous $E = mc^2$). Other types of fields don't entail a mass for particles, like the field theory of quantum chromodynamics and massless gluons.

Your head may be spinning, so here is the bottom line: those things that we call particles are best thought of as the quanta of various relativistic quantum fields—the lowest-frequency ripples that can form. They are the excitations of these fields—whether they're electrons, photons, quarks, gluons, or anything else, from neutrinos to Higgs bosons.

So really, when we talk about the physics of the subatomic we are talking about all the repercussions that come from fields. When you hear scientists get excited about the detection of a Higgs particle, it's not so much the particle that's got them excited—it's the fact that it reveals the existence of the Higgs *field*.

That's one way to think about the subatomic universe. We're brushing up against the very real limits of human knowledge and the constraints of our tools of investigation. Fields, waves, and quanta are just a part of our quest for insight into the underpinnings of the world. They also happen to provide us with some of the most accurate theoretical predictions about the properties of nature ever made in science.

10^{-18}

Interpreting the Physical Universe

The language of mathematics allows us to grapple with the nature of physical reality. But as we move down the layers, from pure mathematics and the basic laws of physics to statistical mechanics and complexity, to relativity, quantum mechanics, and beyond, our understanding is less and less complete.

$$e^{i\pi} + 1 = 0$$

Euler's identity

PURE
MATHEMATICS
AND LOGIC

PROBABILITY

$$\pi$$

$$p(B|A) = \frac{p(A|B)p(B)}{p(A)}$$

Bayes's theorem

3.1415926535897932384626433832795028841971693993751058209749445923078164062862089986280348253421170679821480865132823066470938446095505822317253594081284811174502841027019385211055596446229489549303819644288109756659334461284756482337867831652712019091456485669234603486104543266482133936072602491412737245870066063155881748815209209628292540917153643678925903600113305305

TESTED / KNOWN ←

STATISTICAL
MECHANICS

SPECIAL
RELATIVITY

OTHER
THEORIES

$$S = k_b \ln W$$

Boltzmann
entropy

$$L = L_0 \sqrt{1 - \frac{v^2}{c^2}}$$

Lorentz
contraction

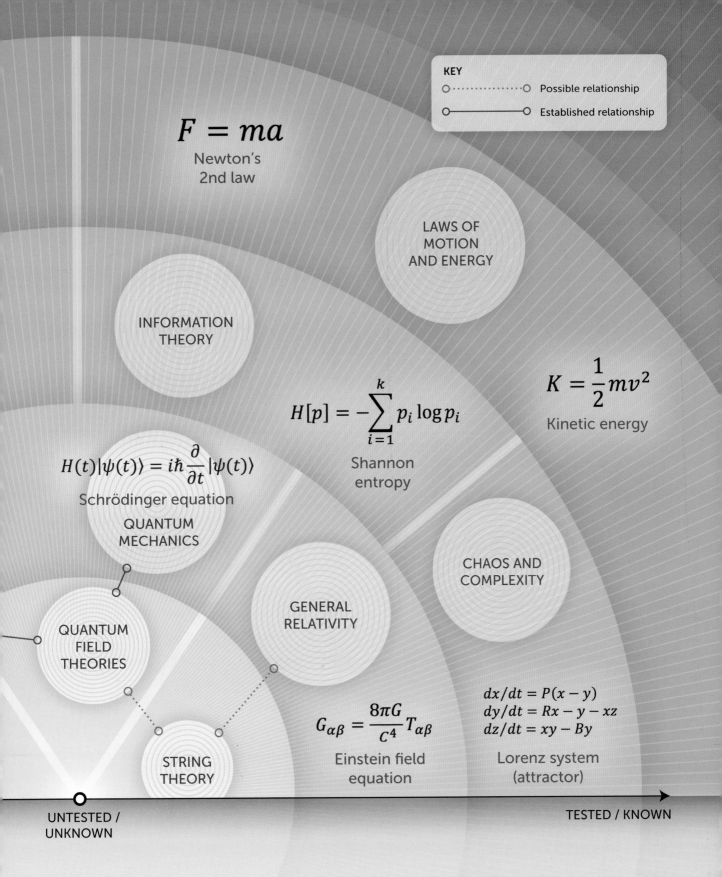

$$F = ma$$

Newton's
2nd law

KEY
○·······○ Possible relationship
○────○ Established relationship

LAWS OF
MOTION
AND ENERGY

INFORMATION
THEORY

$$K = \frac{1}{2}mv^2$$

Kinetic energy

$$H(t)|\psi(t)\rangle = i\hbar\frac{\partial}{\partial t}|\psi(t)\rangle$$

Schrödinger equation

QUANTUM
MECHANICS

$$H[p] = -\sum_{i=1}^{k} p_i \log p_i$$

Shannon
entropy

CHAOS AND
COMPLEXITY

QUANTUM
FIELD
THEORIES

GENERAL
RELATIVITY

$$G_{\alpha\beta} = \frac{8\pi G}{c^4}T_{\alpha\beta}$$

Einstein field
equation

$$dx/dt = P(x - y)$$
$$dy/dt = Rx - y - xz$$
$$dz/dt = xy - By$$

Lorenz system
(attractor)

STRING
THEORY

UNTESTED /
UNKNOWN

TESTED / KNOWN

ALL THE WAY

Our current understanding of the uncertainty principle tells us that somewhere around a scale of 10^{-35} meters the universe runs out of any semblance of acceptable behavior—at least by the rules as we know them.

We know that it takes light about 5×10^{-44} seconds to traverse this distance—yielding the Planck length and the Planck time (two physical constants based on the properties of empty space). We derive these numbers from combinations of other constants of nature—the speed of light, the strength of gravity, the Planck constant (related to the quanta of light and matter), and π. In that sense, these Planck units might at first glance seem to be just amusing number play.

Except we suspect that something important is going on at this scale.

It appears to be the scale where there is no possibility of making genuine measurements anymore; the entire concept of location and time is disrupted by uncertainty. Theoretical physicists have proposed that at this level the very fabric of space-time stops being smooth. Instead, space-time may be "discretized," actually quantized into indivisible bits. At this scale we really need a theory of quantum gravity in order to grapple with reality. We don't have that complete theory yet.

It is also a scale where virtual black holes could appear and disappear, behaving as if they too are the quanta of a field. For the much-discussed idea of string theory, this would also be the smallest meaningful scale: the approximate size of the oscillating strings that make up all elementary particles (yes, strings, fields, quantum gravity, and all of that conflated).

Another appealing proposal for these tiny scales is that space-time itself becomes a *quantum foam*. If this is correct, the simple geometry of space that we're familiar with can no longer hold at such small distances. Instead space-time warps and oscillates, bubbles and jitters with the fury of uncertainty. The idea of quantum foam extends the notion of virtual particles (quanta) appearing and disappearing all the time in empty space. That same virtual "sea" of the vacuum might possibly be related to the dark energy that we saw pushing the universe apart at the largest scales. In the case of quantum foam, it's the very fabric of space-time that is writhing with virtual twists and turns.

Can we ever hope to confirm the existence of this foam? Perhaps one day. On scales of 10^{-19} meters (small, but still a long way from 10^{-35} meters), we have been able to tell that space-

time still appears to be smooth and regular. But what lurks at the bottom of the ladder of size is for now still out of our reach.

END TO END

Here, after passing through more than sixty orders of magnitude in scale, we come to what I'll call "the end for now." Of course, we could also have started here, at the Planck scale, and inflated ourselves upward until we gazed at the observable universe filled with its glinting motes and structures—itself not unlike a composite particle, a place sprinkled with energy and activity.

That journey would have taken us from deep inside a single proton, inside a single carbon atom, inside a twist of deoxyribonucleic acid, perhaps within a single cell of a bacterium, on the

Our cosmic circumstances influence the way we see reality.

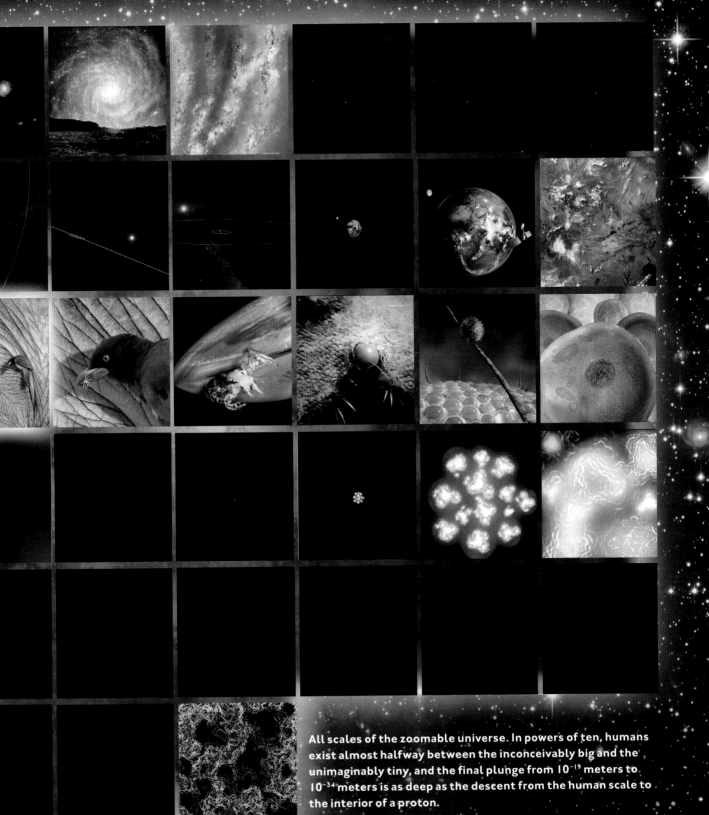

All scales of the zoomable universe. In powers of ten, humans exist almost halfway between the inconceivably big and the unimaginably tiny, and the final plunge from 10^{-19} meters to 10^{-34} meters is as deep as the descent from the human scale to the interior of a proton.

surface of one cell of a louse, captured in the beak of a bird, perched on the leathery hide of an elephant, on a patch of scrub in the Rift Valley on one corner of a great continent on a floating crust of a rocky planet, deep in the gravity well of a single star in lonely interstellar space within a swirling galaxy of gas, dust, and dark matter, part of a group and supercluster of other galaxies, strewn across a swath of a 13.8-billion-year-old void of expanding mostly empty space-time.

Those choices of direction and focus are interesting because they must reflect something about us, our species, but also about the particular circumstances we find ourselves in. What would this book look like if written in a hundred or a thousand years' time? What would it look like if written by another intelligence living a billion light-years from here?

The precise trajectory followed by those hypothetical writers, artists, and designers (or their alien equivalents) would surely be different in its details. Another continent on Earth would be zoomed in on, a different tableau of rock, water, and life. Or perhaps it would be an entirely different type of galaxy: a new stellar host, another planetary home.

Yet that pathway is likely to be familiar in its scope. There are underlying principles at play in nature, from the fields, quanta, and forces of the universe to the ebb and flow of complexity, emergence, and organization. Those principles form a language rich enough to transcend any separation in time or space—we just have to learn how to translate it all.

The odds are good that we'll manage to do more of that translation. Anatomically modern humans have existed for around a hundred thousand years. That's only seven-*millionths* (or 0.0007 percent) of the present age of the universe. We've been around for the tiniest sliver of cosmic time, yet our science can already take us across sixty orders of magnitude in scale.

To put that in perspective, if the age of the universe were a human lifetime, it would have taken the cosmos about five hours to attain its present understanding of itself in the form of us.

Endpoint: The Planck scale, deep in the finest texture of space-time

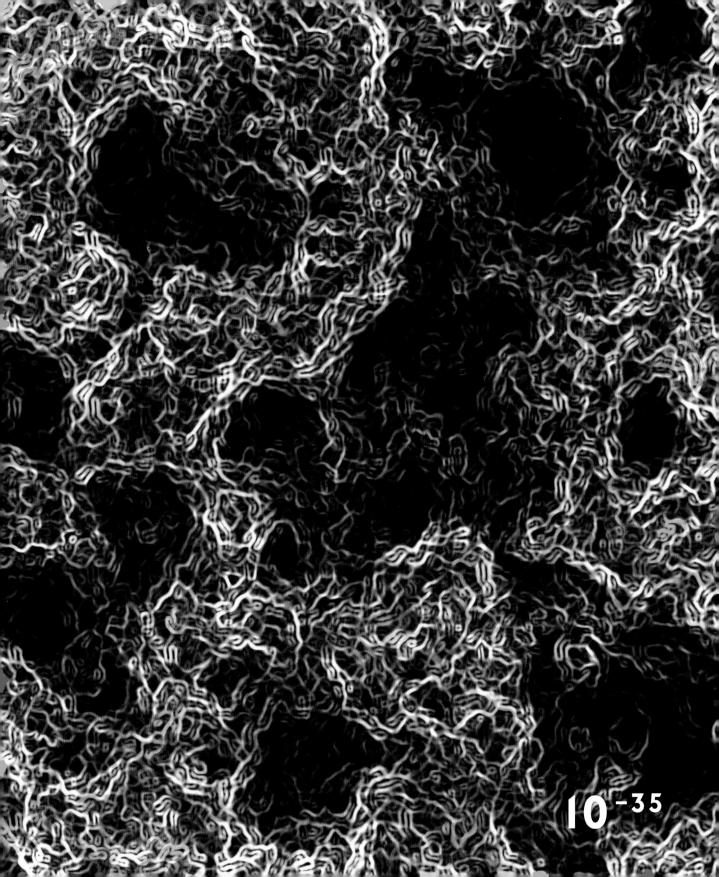

We are accelerating and extending our minds through our computers and algorithms, through our medical prowess and our accumulated knowledge. These minds of ours are the most precious things; we need to cherish all seven-plus billion of them. Walking this rocky globe somewhere today may be a human who will take us to the next level of insight. This person could be anywhere—from Africa to Asia, Oceania to Europe, or in the Americas. This person could even be you.

And that next journey will be at least as extraordinary as this one.

Another place, another story of scale

FROM NEARLY NOTHING TO ALMOST EVERYTHING

What is known to exist at any scale? A very incomplete list.

0.001 fm or less (a femtometer is 10^{-15} meters): Approximate mirror displacement sensitivity of the Advanced LIGO gravitational wave detector at a frequency of 40 hertz

0.84 fm: Effective diameter of a proton

0.1 nm (a nanometer is 10^{-9} meters): Effective diameter of a hydrogen atom

0.14 nm: Effective diameter of a carbon atom

0.8 nm: Average amino acid size

2 nm: Diameter of a DNA alpha helix

4 nm: Globular protein

6 nm: Diameter of actin filaments—part of cellular cytoskeletons

7 nm: Approximate thickness of cell membranes

20 nm: Size of the ribosome

25 nm: Typical outer diameter of a microtubule—tubular structure forming part of a cell's cytoskeleton or structural support

30 nm: Smallest known viruses—porcine circovirus, single DNA loop of only 1,768 base pairs

30 nm: Rhinoviruses (common cold)

50 nm: Nuclear pore

100 nm: a retrovirus like HIV

120 nm: Large virus (orthomyxoviruses, includes the influenza virus)

150–250 nm: Very large virus (rhabdoviruses, paramyxoviruses)

150–250 nm: Smallest known bacteria, such as *Mycoplasma*

200 nm: Centriole—cylindrical organelle in animal cells

200 nm (200 to 500 nm): Lysosomes—organelles in eukaryotic cells involved in producing enzymes that break down proteins, carbohydrates, and more

200 nm (200 to 500 nm): Peroxisomes—organelles in eukaryotic cells that help break down long-chain fatty acids

750 nm: Approximate size of a giant mimivirus

1–10 μm (a micrometer is 10^{-6} meters): The general size range for prokaryotes (bacteria and archaea)

1.4 μm: Maximum length of filamentous Ebola virus (about 80 nm wide)

2 μm: *Escherichia coli*—a bacterium

3 μm: Size of a large mitochondrion inside a eukaryotic cell

4 μm: Size of a small neuron

5 μm: Length of a chloroplast in plant cells

6 μm (3–10 μm): cell nucleus

9 μm: Human red blood cell

10 μm (range 10–30 μm): Most eukaryotic animal cells

10 μm (range 10–100 μm): Most eukaryotic plant cells

90 μm: Small amoeba

120 μm: Size of human egg

160 μm: Largest size megakaryocyte

500 μm: Largest size giant bacterium *Thiomargarita*

800 μm: Large amoeba

1 mm: Diameter of a squid giant nerve cell

40 mm: Largest diameter of the giant amoeba *Gromia sphaerica*

5.8 cm (a centimeter is 10^{-2} meters): Size of Etruscan shrew

12 cm: Diameter of an ostrich egg

1 m: Typical height of a newborn elephant

3 m: Length of longest nerve cells in a giraffe's neck

13 m: Length of (female) giant squid

15 m: Length of adult humpback whale

32 m: Length of adult blue whale

39.7 m: Estimated length of titanosaur *Argentinosaurus huinculensis*

3 km: Approximate size of largest known honey fungus, *Armillaria solidipes*

8.848 km: Height above sea level of Mount Everest

10.994 km: Depth of Challenger Deep—deepest region of Mariana Trench in north Pacific Ocean

16 km: Approximate size of smallest sunspots on the Sun

21 km: Height of Olympus Mons on Mars, measured above global datum

300 km: Diameter of Vredefort asteroid impact crater in South Africa

504 km: Diameter of Saturn's moon Enceladus

950 km: Diameter of Ceres, closest dwarf planet to the Sun

6,000 km: Length of the Great Rift Valley

6,000 km: Approximate length of longest path across Antarctica

6,779 km: Diameter of Mars

92,000–117,580 km: Radii of inner and outer edge of Saturn's B ring

160,000 km: Approximate size of largest sunspots on the Sun

384,400 km: Average distance of the Moon from Earth

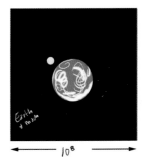

149.6 million km: Average distance of Earth from the Sun

1.643 billion km: Diameter of red supergiant star Betelgeuse

4.28 billion km: Distance at closest approach between Pluto and Earth

8.6 billion km: Diameter of event horizon of a 1-billion-solar-mass black hole

74 billion km (2.86 light-days): Approximate length of all the DNA contained in one human stretched out end to end

40.14 trillion km: Distance to Proxima Centauri

2.35 quadrillion km (24,100 light-years) to 2.69 quadrillion km: Estimated distance to the center of the Milky Way galaxy

2.1 quintillion km (220,000 light-years): Diameter of the Andromeda galaxy (M31)

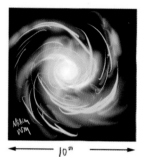

3.1 quintillion km (326,000 light-years): Total length of Cygnus A radio jets from central supermassive black hole

525 quintillion km (55.5 million light-years): Approximate length of all human DNA stretched out end to end (from 7.4 billion currently living people)

13 sextillion km (1.38 billion light-years): Length of the Sloan Great Wall cosmic structure (galaxy filament), about one-sixtieth the size of the observable universe

295 sextillion km (31.217 billion light-years): Co-moving radial distance of farthest cosmic object yet detected—a proto-galaxy seen as it was 400 million years after the Big Bang

880 sextillion km (93 billion light-years): Diameter of the observable universe (co-moving distance)

NOTES

1. Almost Everything

This first chapter is both a scene-setter, a journey plan, and an effort to start conveying the enormity of, well, *everything*. The room full of dust motes came along after an earlier version in which I tried to give a friendly (perhaps rather epistemological) crash course on what we really mean by terms like universe, existence, and so on. Thanks to Amanda Moon for suggesting otherwise.

The facts and figures come from a wide range of sources. Many, like the number of stars in our galaxy or the number of humans who ever lived, are "common knowledge," which scientists soon learn is a way of saying "gross approximation." For example, estimates of the number of stars in the Milky Way are still actively debated, ranging from the 200 billion I quote to as many as 400 billion. New results on the number of galaxies in the observable universe now suggest ten times more than previously thought—bumping us from around 200 billion to over a trillion. See Christopher J. Conselice et al., "The Evolution of Galaxy Number Density at z < 8 and Its Implications," *The Astrophysical Journal* 830, no. 2 (2016): 83.

Discrepancies arise because no one is actually counting stars or galaxies one by one. Instead, for stars in the Milky Way, they're extrapolating from how much light we see from the galaxy, the estimated mass of the galaxy, and how much mass and light we expect each star to contribute. A couple of interesting sources on galactic mass and contents are: Jorge Peñarrubia et al., "A Dynamical Model of the Local Cosmic Expansion," *Monthly Notices of the Royal Astronomical Society* 433, no. 3 (2014): 2204–22; and Timothy C. Licquia and Jeffrey A. Newman, "Improved Estimates of the Milky Way's Stellar Mass and Star Formation Rate from Hierarchical Bayesian Meta-Analysis," *The Astrophysical Journal* 806, no. 1 (2015): 96.

There are many great popular accounts of our current understanding of cosmology. Older but still excellent ones include Steven Weinberg's short *The First Three Minutes: A Modern View of the Origin of the Universe* (updated edition, New York: Basic Books, 1993), and John Gribbin's classic *In Search of the Big Bang: The Life and Death of the Universe* (new edition, New York: Penguin, 1998). More recent reads include Lawrence Krauss's pugnacious but

excellent *A Universe from Nothing: Why There Is Something Rather Than Nothing* (New York: Free Press / Simon and Schuster, 2012), and the relevant parts of Sean Carroll's *The Big Picture: On the Origins of Life, Meaning, and the Universe Itself* (New York: Dutton, 2016).

I mention the idea that our universe might be at least 250 times larger than the present cosmic horizon. That comes from Mihran Vardanyan et al., "Applications of Bayesian Model Averaging to the Curvature and Size of the Universe," *Monthly Notices of the Royal Astronomical Society* 413, no. 1 (2011): L91–L95. As for estimates that the "full" universe is much, much bigger—well, all bets are really off. Cosmic inflation in the early universe can give you almost any size you can stomach—right up to 10-to-the-10-to-the-10-to-the-122. That's from Don N. Page, "Susskind's Challenge to the Hartle-Hawking No-Boundary Proposal and Possible Resolutions," *Journal of Cosmology and Astroparticle Physics* 2007, no. 1 (2007): 004. Really, no wonder many physicists end up in finance.

I find multiverse ideas equal parts fascinating, logical, and "you must be kidding." It's hard not to admit that from a physics point of view there are a lot of theoretical ideas pointing in this direction. But, to use the old adage: extraordinary claims require extraordinary evidence—and that evidence has not yet made itself known to us.

The "foaminess" of the cosmos, sometimes referred to as the "cosmic web," is a remarkable aspect of the universe. This large-scale texture is mainly driven by the way gravity pulls together the primordial distribution of matter, and that matter's primordial velocity field. Two projects that give insight into the cosmic matter distribution are the Sloan Digital Sky Survey (www.sdss.org) and the 6dF Galaxy Survey (www.6dfgs.net).

2. Darkness and Light

The general emptiness of the universe (across all scales) is a very hard thing to appreciate without some extreme thought experiments. To make the back-of-the-envelope calculations here, I've assumed all stars are the same physical size, which they're not—most stars are less than about 70 percent of the radius of the Sun, while rare giant stars can be a thousand times larger. Taking the Sun's radius as an average is a rough-and-ready approximation. I debated discussing black holes here, but feel that it's important to point out what physics does and doesn't allow. It is also nicely counterintuitive that the physical size of a black hole (defined by the event horizon) doesn't scale with mass the way it does with "normal" matter.

The numbers for the density of matter in interstellar and intergalactic space are typical, average values. There are lots of variations. These data are sourced from a century of astronomical observations.

Intergalactic voids are a fascinating manifestation of the primordial variations in matter density on very large scales in the cosmos. They tend to "self-clean," because low-density cosmic regions (of about 10 million to over 100 million light-years across) experience slightly greater cosmic expansion rates. Galaxies in voids also show signs of somewhat different histories and properties. A review can be found in P.J.E. Peebles, "The Void Phenomenon," *The Astrophysical Journal* 557, no. 2 (2001): 495–504.

Our vision of the Milky Way, Andromeda, and all these other satellite galaxies has evolved enormously in the past twenty years. A lot of new, small galaxies have been discovered because of advances in machines and computation. It's a great example of "big data." Mapping and analyzing millions to billions of stars and their colors has allowed astronomers to recognize faint, smeared-out galaxies lurking behind the veil of stars of the Milky Way—the stuff we always have to look through to study the rest of the cosmos. See, for example, Martin C. Smith et al., "The Assembly of the Milky Way and Its Satellite Galaxies," *Research in Astronomy and Astrophysics* 12, no. 8 (2012): 1021.

The dark matter problem keeps dodging our best attempts to solve it. Right now there's a growing sense in the

physics community that either dark matter is even more exotic in nature than we thought (made of particles with fancier properties), or we're getting something horribly wrong.

The central regions of the Milky Way must be extraordinary to witness—by comparison, we live in a dank cave on the outskirts of civilization. Of course, we don't know if anything is witnessing it. The artwork here really gets at the sheer brightness of the environment—and was a lot of fun to produce.

Describing our galaxy is tricky, because the truth is, we still don't have all the details figured out. Mostly, that's because we can't see the galaxy very easily; we're too deep inside it, in the weeds. Hopefully we'll do better. Space observatories like the GAIA mission are going to revolutionize our maps of at least parts of the Milky Way. Take a look: http://sci.esa.int/gaia.

The infographic of galaxy sizes is quite startling. Over the years there's been debate on how the Milky Way stacks up against other galaxies, but there's little doubt now that there are some monsters out there. See, for example, Juan M. Uson et al., "Diffuse Light in Dense Clusters of Galaxies. IR-Band Observations of Abell 2029," *The Astrophysical Journal* 369 (1991): 46–53.

There is constant churn in the positions of stars in a galaxy, including ours. See, for example, C. A. Martínez-Barbosa et al., "The Evolution of the Sun's Birth Cluster and the Search for the Solar Siblings with *Gaia*," *Monthly Notices of the Royal Astronomical Society* 457 (2016): 1062–75.

3. The Slow, the Fast, and the Fantastic

This is a tough set of scales to deal with. The fact is that the visual journey from 10 light-years to 92 light-hours (roughly the span here)—zooming in on the solar system—just doesn't look very exciting to human eyes. We had some gnashing of teeth to figure out what to do. We could have just kept it dull and realistic, but we realized that doing so would miss the deep connections between past and present. It wasn't always this boring! That's why this chapter simultaneously zooms in through space and zooms through time (as well as states of matter)—starting about five billion years ago.

The first stars in the cosmos are critical, and still poorly understood: see Volker Bromm, "The First Stars," *Annual Review of Astronomy and Astrophysics* 42 (2004): 79–118.

You could write a whole book on how stars make elements and disperse them into the cosmos, and people have. A nice read is Jacob Berkowitz's *The Stardust Revolution: The New Story of Our Origin in the Stars* (Amherst, New York: Prometheus Books, 2012).

The astrophysics of forming stars and proto-stellar disks, proto-planetary disks, and planets is a hot topic. In fact, it's really another of the frontier areas in science where we're getting deluged with new data. The illustrations here (among my favorites in the whole book) reflect that new data. Apart from the Hubble Telescope and other observatories, some of the most exciting images and insights are coming from the Atacama Large Millimeter/submillimeter Array (ALMA)—perched on a Chilean plateau at an altitude of 5,000 meters. Just stunning: www.almaobservatory.org.

The questions that come up about the solar system's final birthing process (Earth's water content, Mars's mass, the curious paucity of inner planets) are also at the forefront of modern research. An example of a review of the field is S. Pfalzner et al., "The Formation of the Solar System," *Physica Scripta* 90, no. 6 (2015): 068001.

Sometimes astronomers talk about our present-day solar system as a "fossil." It's not a bad analogy: the most energetic and diverse action happened 4.5 billion years ago in our system. We just live in the gently evolving remains of that birth period. See, for example, John C. B. Papaloizou and Caroline Terquem, "Planet Formation and Migration," *Reports on Progress in Physics* 69, no. 1 (2006): 119.

4. Planets, Planets, Planets

Full disclosure: this was actually the first chapter drafted for the book. I wanted to come up with a way to connect the scale of the solar system to our everyday scales—which is difficult. Waving a flashlight at the night sky is something I remember doing as a kid, watching the beam fade as it climbed upward. Somewhere those photons (or some of them) are still racing out into the cosmos—which is pretty neat when you think about it!

Exoplanets are of course big news. Before the mid-1990s, we just didn't know how many stars also had planets around them. Now we know that they basically all do. My book *The Copernicus Complex* (New York: Scientific American / Farrar, Straus and Giroux, 2014) goes pretty deep into the science surrounding other worlds. There are also many other sources. If you want an up-close-and-personal look at the latest raw data on exoplanets, two sites are very useful: http://exoplanet.eu (The Extrasolar Planets Encyclopaedia) and http://exoplanets.org.

Statistical extrapolations about exoplanet populations have been carried out by many researchers. A couple of good examples are: Courtney D. Dressing and David Charbonneau, "The Occurrence of Potentially Habitable Planets Orbiting M Dwarfs Estimated from the Full Kepler Dataset and an Empirical Measurement of the Detection Sensitivity," *The Astrophysical Journal* 807, no. 1 (2015): 45, and Daniel Foreman-Mackey et al., "Exoplanet Population Inference and the Abundance of Earth Analogs from Noisy, Incomplete Catalogs," *The Astrophysical Journal* 795, no. 1 (2014): 64.

Evidence for the "Steppenwolf" planets is still somewhat controversial, and comes from gravitational microlensing data. My guess is that some studies may overestimate this population, but that there really are some lonesome worlds, ejected from their birth systems by orbital instabilities.

The illustration of the surface view on Proxima b is actually the product of a significant amount of scientific thought. The closeness of Proxima b to its flare-prone, low-mass (reddish-hued) star suggests that to maintain an atmosphere the planet would also need a strong magnetic field. A magnetic field would likely help cause an aurora in that atmosphere and would also go hand in hand with a geophysically active world. Hence the depictions of these various features.

As with a lot of things in physics and geophysics, we oversimplify planetary interiors both because we don't have enough information to do better, and also because we like to simplify physical systems in order to get an intuitive grasp on them. If you wonder how complicated a rocky world like Earth really is, just go look at the latest geophysics research, like Kei Hirose et al., "Composition and State of the Core," *Annual Review of Earth and Planetary Sciences* 41 (2013): 657–91, and George R. Helffrich and Bernard J. Wood, "The Earth's Mantle," *Nature* 412 (2001): 501–7.

As I started writing the text for this book, NASA's New Horizons mission had, a few months earlier, made its historic fly-through of the Pluto system. While no one really knew what to expect, I don't think many people anticipated just how interesting and complex Pluto would be. This icy world is set to revolutionize our mindset: being stuck out at the start of a planetary system's frigid end zone does not make a planet inactive or boring. Check out http://pluto.jhuapl.edu.

I find tides quite fascinating, so of course I had to include them here. Planetary tides result in the dissipation of energy—both the spin energy of a planet or moon (and even of the Sun!) and the energy of orbits. These slow power seeps literally reshape objects and orbits across the universe. For a technical study of the implications for "exomoons," I'll shamelessly point to a paper of mine: C. A. Scharf, "The Potential for Tidally Heated Icy and Temperate Moons around Exoplanets," *The Astrophysical Journal* 648, no. 2 (2006): 1196–1205.

5. A World We Call Earth

In the opening of this chapter I wanted to emphasize several specific ideas—including the fact that what we think of as Earth is really just the planet as it happens to be at this moment. Throughout its 4.5-billion-year history Earth has

seldom, if ever before, been exactly the way it is now. And that trend will continue into the future. I also wanted to emphasize certain planetary characteristics that we often take for granted. The graphic of Earth's surface-water content, for example, is pretty stunning. We may be an ocean world, but all those oceans don't actually add up to very much at all! The United States Geological Survey Web pages are a treasure trove of interesting information: https://www.usgs.gov and http://water.usgs.gov/edu/earthhowmuch.html.

The oldest rocks on Earth remain a little controversial. But the zircons are compelling. An example of the fascinating research done on zircons includes the discovery of diamond inclusions inside zircons—providing clues to Earth's tectonic processes more than four billion years ago. See Martina Menneken et al., "Hadean Diamonds in Zircon from Jack Hills, Western Australia," *Nature* 448 (2007): 917–20.

There's still considerable debate over the organisms that polluted Earth's atmosphere with oxygen, and exactly what the timeline of that pollution was. See, for example, Donald E. Canfield et al., "Oxygen Dynamics in the Aftermath of the Great Oxidation of Earth's Atmosphere," *Proceedings of the National Academy of Sciences* 110, no. 42 (2013): 16736–41. The standard lore is that cyanobacteria were the prime oxygenating culprits. Maybe they were, maybe they weren't.

The amount of energy Earth receives from the Sun is enormous. Hopefully that is conveyed here. The estimates of human energy consumption are just that: estimates. For example, the International Energy Agency (IEA) provides some data and calculation: https://www.iea.org.

Climate and weather are very complicated phenomena (strictly speaking, climate is just the statistics of weather—the time-averaged, rounded-off likelihood of certain properties like surface temperature or ice cover). I've given a very simplistic overview here. Given the urgency of facing up to human-induced climate change (it's happening, it's just physics, don't argue), you might want to stay informed. Good resources include www.noaa.gov/climate, http://climate.nasa.gov, and www.metoffice.gov.uk/climate-guide.

Powerful typhoons (in the Indian Ocean or western Pacific) or hurricanes (northeast Pacific and north Atlantic)—collectively known as tropical cyclones—are astonishing. You'll find all sorts of ways scientists try to convey the power involved: one day of such a storm's energy is equivalent to hundreds of thermonuclear bombs, or could power human civilizations for years.

Sunlight changing chemistry is a big deal. This photochemistry isn't just important for Earth, it's part of what happens throughout the solar system and beyond. A very technical but comprehensive insight can be had in Renyu Hu et al., "Photochemistry in Terrestrial Exoplanet Atmospheres I: Photochemistry Model and Benchmark Cases," *The Astrophysical Journal* 761, no. 2 (2012): 166.

I struggled to find a way to express a vision of the Earth in very human terms. Then it occurred to me that there were people who'd seen our world from space. I knew many had written of their experiences, but I hadn't realized how many recollections there are, or how eloquent they could be. These quotations are in the public record, and there are many more not shown here. I tried to span our varied countries and cultures a little. (See, for example, www.spacequotations.com/earth.html.)

6. Being Conscious in the Cosmos

You might be surprised that I talk about consciousness in this chapter. Me too. But I started thinking about what aspect of our world is the most striking on these scales. What could be said about living organisms, like humans, elephants, birds, and so on, that hasn't been said many times before? To be honest, I think the puzzles of awareness, self-awareness, sentience, and that thing we call consciousness are some of the biggest unanswered questions we have.

The other big puzzles include how all the living systems on Earth are intertwined with one another—not just now, but across time. It's a bit clichéd, but if you've never looked at what Charles Darwin, Alfred Russel Wallace, Alexander von Humboldt, and others wrote as they pieced together what would become our understanding of evolution, it's worth doing so. The Darwin Online resource is terrific: http://darwin-online.org.uk. You can find Wallace's works on natural selection in many online resources (he even thought about astrobiology!), and Michael Shermer has written an excellent biography, *In Darwin's Shadow: The Life and Science of Alfred Russel Wallace: A Biographical Study on the Psychology of History* (Oxford, UK, and New York: Oxford University Press, 2002). On Humboldt, see Andrea Wulf's wonderful *The Invention of Nature: Alexander von Humboldt's New World* (New York: Knopf, 2015).

Estimates of biomass are notoriously tricky. You can't sample every cubic meter of the Earth's upper layers and count organisms; you have to perform some major extrapolations from localized counts, data on fluxes of food and refuse, and so on. An example focused on the global biomass in forests is a review by Yude Pan et al., "The Structure, Distribution, and Biomass of the World's Forests," *Annual Review of Ecology, Evolution, and Systematics* 44 (2013): 593–622. An example of an estimate of microbes' biomass that revises the total significantly downward is Jens Kallmeyer et al., "Global Distribution of Microbial Abundance and Biomass in Subseafloor Sediment," *Proceedings of the National Academy of Sciences* 109, no. 40 (2012): 16213–16.

Perhaps the biggest choice that I had to make in the book was exactly *where* to zoom in as our journey reached Earth. It seemed important to avoid what had been done in the past (repetition is never so interesting) and too much Western and Northern Hemisphere bias. Modern humans all come from Africa. It's also a continent of remarkable geography and biological diversity. And the Great Rift Valley is such an imposing feature—a place where the Earth's crust is literally at its thinnest, a reminder of our perilous tenure even in the midst of swarming life. I also like elephants. They're fascinating aliens, beautiful, and in need of our appreciation and protection.

Information about *Homo habilis* and *Homo erectus* is widely available, but a very good read with the latest insights is Yuval Noah Harari's *Sapiens: A Brief History of Humankind* (New York: HarperCollins, 2015).

The "tree of life" is a popular conceptual model for the branching evolutionary landscape of living things. It goes back to Darwin, among others. Versions based entirely on fossil records and taxonomy are limited. More-modern phylogenetic trees are more powerful. Both help us get a general picture of who is related to whom. There are various resources online: www.tolweb.org, www.wellcometreeoflife.org/interactive, and tree.opentreeoflife.org.

Insect intelligence and cognition is particularly fascinating given how different we are. Some recent research suggests (quite convincingly, in my opinion) that not only can bumblebees "innovate" to solve physical puzzles, but those that manage this can then "teach" other bees (or at least other bees learn quickly from their successful kin). And once taught, bees can then serve as models for later bee generations. Pretty amazing. See Sylvain Alem et al., "Associative Mechanisms Allow for Social Learning and Cultural Transmission of String Pulling in an Insect," *PLOS Biology* 14, no. 10 (2016): e1002564.

Exactly what brains can do in different species is a very tough question to answer. The infographic in this chapter has a lot of uncertainty in it—which is fine, that's how science is.

I mention the term "contingency." This has strong connotations in evolutionary biology, particularly due to the writings of Stephen Jay Gould. All his books are provocative and interesting, but *Wonderful Life: The Burgess Shale and the Nature of History* (New York: W. W. Norton, 1989) is a must-read—even if you don't agree with the specifics of his proposals.

7. From Many to One

"Complexity" and "complex systems" have become a critical part of the modern scientific lingo, and with good reason—the universe is full of complexity. But complexity challenges our reductionist tendencies, and is something that we're still coming to grips with. There are many texts to refer to, some popularized, some technical. See, for example, James Gleick's classic *Chaos: Making a New Science* (New York: Viking Penguin, 1987), and Stuart Kauffman's *At Home in the Universe: The Search for the Laws of Self-Organization and Complexity* (Oxford, UK, and New York: Oxford University Press, 1995). It's worth looking at the activities of a place where so much of this work has come from: the Santa Fe Institute in New Mexico, www.santafe.edu.

On the microscopic world, it's worth reading about Antonie van Leeuwenhoek, who pioneered microscopy and was probably one of the first humans to actually see bacteria, back in the 1600s and early 1700s.

I chose the human hand to exemplify the granularity of life because it's such an intimate appendage and an iconic shape. It's what has literally enabled us to take over the world. The mathematician and intellectual Jacob Bronowski once said, "The hand is the cutting edge of the mind."

The earliest evidence for multicellular life on Earth is claimed to be in the form of fossils from Gabon dating from 2.1 billion years ago. See, for example, Abderrazak El Albani et al., "The 2.1 Ga Old Francevillian Biota: Biogenicity, Taphonomy and Biodiversity," *PLOS One* 9, no. 6 (2014): e99438. Of course, this is only the earliest possibility found thus far. It has been claimed that multicellularity has been "invented" (via natural selection and environmental pressure) on Earth as many as forty-five times.

The mathematical relationship between basal metabolic rate and organism mass is pretty remarkable. See, for example, Geoffrey B. West et al., "A General Model for the Origin of Allometric Scaling Laws in Biology," *Science* 276 (1997): 122–26.

Scaling laws and human cities are also amazing. See Geoffrey West's lovely essay on this, "Scaling: The Surprising Mathematics of Life and Civilization," https://medium.com/sfi-30-foundations-frontiers/scaling-the-surprising -mathematics-of-life-and-civilization-49ee18640a8.

Swarms and flocks are fascinating, and a number of researchers study these to try to learn about the emergence of complex phenomena from simple rules, and also about how organisms learn and adapt. The research area is often called "swarm behavior" or "swarm dynamics." It lends itself to examination through software simulations and robotics.

The ant colony's "shortest path" optimization has spawned a small field of research, generating computational/ algorithmic approaches to solving hard problems that can be represented as graphs—where a shortest path through is the solution. This literally all began by studying ants. See, for example, J. L. Deneubourg et al., "Probabilistic Behaviour in Ants: A Strategy of Errors?," *Journal of Theoretical Biology* 105 (1983): 259–71.

I mention entropy at the end of this chapter. Entropy is worthy of an entire book in itself. A concept close to the core of modern physics, it is quite hard to grasp and is still not fully understood.

8. The Undergrowth

There were several options for how to handle this chapter. One was to just plunge ahead and ignore the physical impossibility of "observing" these scales the same way that we've observed the larger ones. Instead, I chose to confront the bizarreness of these scales head-on and to try to show the transition to the atomic—setting the stage for the following chapters too.

The data on DNA lengths in the infographic is perhaps the most shocking thing in this chapter (well, almost as

shocking as the reveal of the quantum world). The numbers are robust: if you could lay out a single strand of human DNA (over three billion nucleotides in size) in an untwisted, uncurled state, it'd be a 1.8-meter-long invisible thread. All the other numbers flow from this, once you include an estimate of approximately 40 trillion cells in a human body (a more recent and conservative estimate than the 100 trillion that often gets quoted). The total length of all human DNA is crazy, I know, but that's what you get.

Not all bacteria look alike. We've chosen one with a tail and a "pill-like" shape because it's perhaps more visually appealing. There is actually a wide range of single-cell morphologies.

Microbes are the real rulers of our planet. They're also the real rulers of us. If you want to upset yourself (in a great way), read Ed Yong's *I Contain Multitudes: The Microbes Within Us and a Grander View of Life* (New York: HarperCollins, 2016).

Except, if microbes are the real rulers, what are viruses? It's possible that viruses are every bit as much "in charge" as the organisms above them; we just have a hard time characterizing viruses as "alive." Another great popular account is Carl Zimmer's *A Planet of Viruses* (Chicago: University of Chicago Press, 2011).

Someone should write a lay reader's account of the ribosome—perhaps they have, but I've not come across a good one. A ribosome in our cells is more than fifty proteins plus RNA. It's a crazy thing. Nick Hud at Georgia Tech gave me a crash course one sweltering day in Atlanta a few years ago, so here's a good reference, including his research group: Anton S. Petrov et al., "History of the Ribosome and the Origin of Translation," *Proceedings of the National Academy of Sciences* 112, no. 50 (2015): 15396–401.

I mention the electrical stickiness of things at small scales. It's a reminder that chemistry is all about electromagnetism. Even though electromagnetism is actually mediated by the exchange of photons, it's not like you can "see" these photons in the way you do on human scales.

Getting diffracted as you pass through a doorway is an old physics trope. I've heard jokes told in academia about how you can use this to escape a tiger that's chasing you. Jump into a hut and stand in the place where the diffraction pattern of the tiger is at a minimum (see the next chapter too). This kind of tale goes back to the physicist George Gamow's charming educational stories of Mr. Tompkins, such as *Mr. Tompkins in Wonderland*, published in 1940; a modern collection is *Mr. Tompkins in Paperback* (Cambridge, UK: Cambridge University Press, 1993, 2012). Tompkins's journeys include going inside the atom.

To figure out how much you can actually diffract in going through a normal-size doorway as a normal-size human, you must first work out your de Broglie wavelength and use de Broglie's equation, which allows you to compute the velocity (or momentum) you need to diffract by some noticeable amount. Turns out you have to be going really, really slowly—less than 10^{-34} meters a second—so it would actually take you trillions of times longer than the age of the universe to get across the threshold.

I'm often asked whether nature could use elements other than carbon to make life. It's possible, but carbon really does hit the mark, for the reasons I give in the text. Its combination of bond formation, reactivity, and stability is pretty special.

Coming up with the infographic of the life of a carbon atom was fun but challenging, because there are simply so many pathways any single carbon atom in your body could have taken. In the last steps I decided to have us ingest the carbon in "organic matter" stuck to the potato. Otherwise it would have to go through another cycle in the atmosphere before incorporating into a plant.

Understanding the production of carbon by stars was one of the triumphs of twentieth-century astrophysics and nuclear physics. But it also leads to some intriguing discussions on the "fine-tuning" of the cosmos. A rather fun, but

technical, recent paper takes this all a bit further: Fred C. Adams and Evan Grohs, "Stellar Helium Burning in Other Universes: A Solution to the Triple Alpha Fine-Tuning Problem," https://arxiv.org/abs/1608.04690.

Anthropic arguments are indeed good fodder for discussion. You can find many sources to delve into on this topic (including my earlier books). A balanced and modern one is Martin Rees's *Just Six Numbers: The Deep Forces That Shape the Universe* (New York: Basic Books, 2000).

9. The Emptiness of Matter

Here I'm back complaining about how empty the cosmos is—just like in Chapter 2. It is astonishing how little space is really occupied by the matter of an atom—although of course the electrons do occupy all the space in an atom, they only do so probabilistically.

The nature of quantum mechanics, and its description of the atomic and subatomic world, is very challenging to convey. Here I decided to try to be reasonably honest. Quantum mechanics is an incredibly successful framework—yet it's also not clear what the best model is for its underlying properties. We thought about illustrating the Schrödinger's Cat experiment in different interpretations, but that proved not to allow a clear enough distinction. The two-slit, or double-slit, experiment hit the mark.

The de Broglie–Bohm interpretation seems to be getting a bit more press these days. In part this is because of some intriguing experimental work. See Dylan H. Mahler et al., "Experimental Nonlocal and Surreal Bohmian Trajectories," *Science Advances* 2, no. 2 (2016): e1501466.

The idea that in a many-worlds interpretation the electrons passing through a double-slit experiment get "buffeted" by those in parallel realities comes from some recent proposals. Here the parallel realities are "classical" in the sense that quantum effects arise solely *because* of the interaction of these other worlds—if you took away the other realities you'd be left with a classical non-quantum world (which would presumably also mean the end of us all). See Michael J. W. Hall et al., "Quantum Phenomena Modeled by Interactions between Many Classical Worlds," *Physical Review X* 4, no. 4 (2014): 041013.

Entanglement and non-locality are a beast to get your head around. I recommend George Musser's excellent *Spooky Action at a Distance: The Phenomenon That Reimagines Space and Time—and What It Means for Black Holes, the Big Bang, and Theories of Everything* (New York: Scientific American / Farrar, Straus and Giroux, 2016).

I mention isotopes because it intrigues me that at what is, to us, such a fundamental level (atomic nuclei), nature is still kind of messy. These nuclei are far from elegant. Yet at the same time, isotopes are so very useful for us in figuring out the workings of the cosmos. I can't resist citing the following paper: L. G. Santesteban et al., "Application of the Measurement of the Natural Abundance of Stable Isotopes in Viticulture: A Review," *Australian Journal of Grape and Wine Research* 21, no. 2 (2015): 157–67. Bet that's the first time this journal has been cited in a book like this.

How do you make super-heavy nuclei like oganesson (ununoctium)? You can bash other heavy nuclei into each other in the hope that something new sticks—basically. As that heavy nucleus undergoes radioactive decay (typically very quickly), you can look for the decay products and figure out what was formed.

I decided not to go very deep into particle physics in this chapter, beyond introducing quarks and gluons and illustrating the particle families. There are lots of good popular accounts of this science, going back over many decades—and I wanted to keep the sense of descent going. We can catch fleeting glimpses along the way of the rich variety of structures at this scale, but we must plunge on.

This statement on incomprehensibility is indeed Einstein's sentiment, but he didn't use exactly these words. The

original source, where the wording is somewhat different ("One may say 'the eternal mystery of the world is its comprehensibility' "), is Albert Einstein, "Physics and Reality," 1936, reprinted in Einstein, *Ideas and Opinions* (New York: Crown, 1954, 1982).

10. It's Full of . . . Fields

We faced two choices here: depict nineteen orders of magnitude of unknown textures, seething virtual particles, the same, same stuff at all these scales, or skip most of it. I think we made the right decision. But it wasn't taken lightly. We just assume it's kind of boring across these tiny scales, but we don't really know.

Shifting the emphasis from "particle and wave" to "field and quanta" is, I think, important. It serves to introduce us to the mathematical machinery that modern physics uses, but it also (I hope) helps give a sense that we're approaching the ultimate, rock-bottom fundamentals of the cosmos.

A good, classic read is Richard P. Feynman's *QED: The Strange Theory of Light and Matter* (Princeton: Princeton University Press, 1986), as well as his other books and lecture notes.

How to depict the final scale—Planck's 10^{-35} meters—was quite a challenge. To be honest, we could have done almost anything here and it would be valid. In the end, I like the texture and depth of our visual—it's restrained, but it makes your eyes hurt just a little.

The idea of "quantum foam" apparently arose in the mind of the physicist John Wheeler in the course of discussions with his colleague Charles Misner in the mid-1950s, or so he claimed: John Archibald Wheeler with Kenneth Ford, *Geons, Black Holes, and Quantum Foam: A Life in Physics* (New York: W. W. Norton, 1998). Work that may be able to test for signs of quantum foam includes Fermilab's Muon g-2 experiment. For string theory and other arcana of ultra-physics, readable sources include Brian Greene's *The Elegant Universe: Superstrings, Hidden Dimensions, and the Quest for the Ultimate Theory* (New York: W. W. Norton, 1999, 2003).

The final infographic here is a way of depicting the layers of "translation" that we apply to understanding the universe around us, starting with pure mathematics and moving inward to physics. The equations on this graphic are just a few of those we could have chosen—they're an attempt to cherry-pick the most interesting. In that sense they reflect the whole idea of this book: it's a big universe, with lots of fun trips; we've just chosen one of those journeys.

In the final text here I (again) mention computers. I'm really alluding to artificial intelligence. The latest deep-learning systems (with tens of "hidden layers" of software neural nets) are doing something we've never seen before in computation. It's a little scary, a lot exhilarating. We could be at the tipping point where our minds are extended outside their biological confines. It's going to be an interesting future.

ACKNOWLEDGMENTS

The original idea for this book grew from early conversations with Deirdre Mullane of Mullane Literary and Amanda Moon at Farrar, Straus and Giroux. Without their enthusiasm, and a great deal of their patience, this project wouldn't have got past the first centimeter in scale.

Those initial rounds of lunch-fueled cogitation led us to focus on the relationship of the natural world with itself—in scale, time, and energy. As we added ideas like complexity, emergence, and chaos, the vision of the book crystallized. To get from almost everything to nearly nothing has been a fun trip in its own right. I've had the very great privilege of working with Ron Miller and his supreme illustration skills and imagination, as well as the graphic prowess of Samuel and Juan Velasco of 5W Infographics. All of you have shown me what it's like to work with real professionals, time and time again. And in that same vein I'd like to thank all the other members of the FSG team, especially Jonathan Lippincott and Scott Borchert. A special shout-out also goes to Annie Gottlieb, whose copyediting skills have made innumerable improvements to the text.

Some of this book took shape during long flights between New York and Tokyo, and in many tranquil moments in Japan. I'd like to express my gratitude to all the scientists and staff at the Earth-Life Science Institute at the Tokyo Institute of Technology for throwing fuel onto the fires of inspiration at many points. A special thank-you goes to Piet Hut for planting the seeds for all of that to happen, and for what I expect to be future crops.

To many other friends and colleagues, including Mary Voytek, Frits Paerels, David Helfand, Amber Miller, Michael Way, Nelson Rivera, Daniel Savin, Arlin Crotts, Ayako Fukui, Windell Williams, Abigail and Lewis Wendell, Eric Gotthelf, and Fernando Camilo, thank you for all your support and encouragement.

Finally, as always, my home team: Bonnie, Laila, Amelia, and Marina, thanks for putting up with all of this.

—Caleb Scharf
New York, 2016

I've always been fascinated by the very, very large and the very, very small. The first probably came from the interest in astronomy and space travel I've had pretty much all my life. The latter might come from having seen *The Incredible Shrinking Man* when it was first released in theaters (I refuse to look up the year that happened)—but I may have wanted to see the movie because I had already read a short story by Henry Hasse called "He Who Shrank," which turned the whole idea of macro- and microverses upside down. I also remember a book I devoured in grade school called *The Thirteen Steps to the Atom* that took me on a step-by-step photographic journey from my familiar world to the almost infinitely small. I discovered the classic *Cosmic View* around the same time—and still have my original copy. I remember when Charles and Ray Eames's *Powers of Ten* came out, in 1977; I must have watched it a dozen times then and I don't know how many times since. So when I was offered the chance to illustrate this book, I jumped at it, if for no other reason than that it presented an immense challenge. I had never done anything like it before. No problem with the zoom from the edge of the universe to Earth—I was on familiar territory there—but as the book dove ever deeper into the very small, I was exploring new subjects, ideas, and techniques. An especial challenge was having to illustrate things that literally could not be seen, or even measured, for that matter . . . things that in many cases barely had any reality at all.

It also gave me a chance to work again with Amanda Moon, and to work for the first time with Caleb Scharf, whose writing I absolutely couldn't admire more. All to say nothing of the pleasure of associating with the rest of the book's wonderful team: Scott Borchert and Jonathan Lippincott. And, as always, a grateful tip of the hat to the ever-patient Judith Miller.

—Ron Miller
South Boston, Virginia, 2016

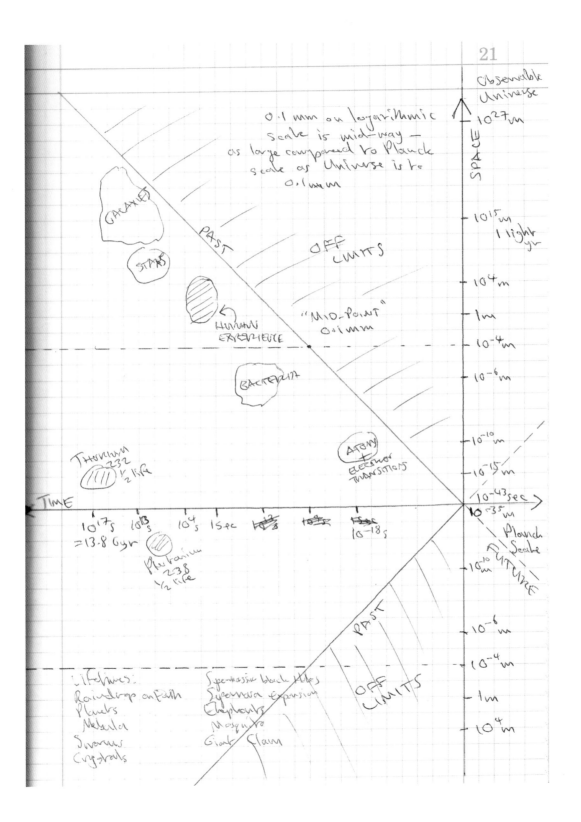

A Note About the Author

Caleb Scharf is the award-winning author of *The Copernicus Complex* and *Gravity's Engines*, and the director of the Columbia Astrobiology Center. He has written for *The New Yorker*, *The New York Times*, *Scientific American*, *Nautilus*, and *Nature*, among other publications. He lives in New York City. Follow him on Twitter at @caleb_scharf.

A Note About the Illustrator

Ron Miller is an award-winning illustrator and author whose work has appeared in *National Geographic*, *Scientific American*, the bestselling app Journey to the Exoplanets, and editions of *20,000 Leagues Under the Sea*, *Journey to the Center of the Earth*, and many other books. He served as art director for the National Air and Space Museum's Albert Einstein Planetarium. He lives in Virginia. Visit his website at www.black-cat-studios.com.

A Note About the Infographics

5W Infographics is an award-winning design and consulting company that specializes in infographics, data visualization, and information-driven visual projects. It was founded by Juan Velasco and Samuel Velasco in 2001. Juan was art director of *National Geographic* from 2008 to 2014 and was previously the graphics art director for *The New York Times*. Samuel Velasco is a former art director of *Fortune* and is also an award-winning illustrator. Visit 5W's website at www.5wgraphics.com.